other oceans

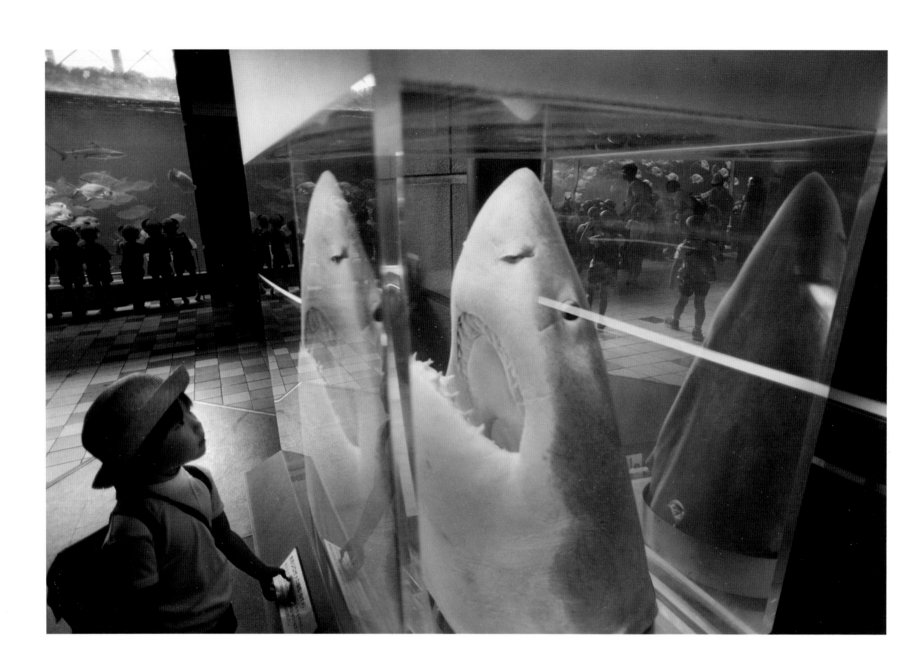

other *oceans*

Photographs by
Wayne Levin

Introduction by Thomas Farber

Essays by Bruce A. Carlson & Frank Stewart

A Latitude 20 Book
University of Hawai'i Press
Honolulu

Printed in Canada by Friesens Corporation

Library of Congress Cataloging-in-Publication Data
Levin, Wayne
Other oceans / photographs by Wayne Levin ; introduction by Thomas Farber ; essays
by Bruce A. Carlson and Frank Stewart .
p. cm.
ISBN 0-8248-2509-8 (cloth : alk. paper)—ISBN 0-8248-2510-1 (pbk. : alk. papr)
1. Marine aquariums, Public. 2. Marine aquariums, Public—Pictorial works. I. Carlson,
Bruce A. II. Stewart, Frank, 1946- III. Title.

QL78.5 .L48 2001
591.77'073—dc21
2001033602

University of Hawai'i Press books are printed on acid-free paper
and meet the guidelines for permanence and durability of the
Council on Library Resources.

Front cover photograph: Tokyo Sea Life Park, Japan
Cover background photograph: *Akule* over sand, Hawai'i
Back cover photograph: Hakejima Sea Paradise, Yokohama, Japan

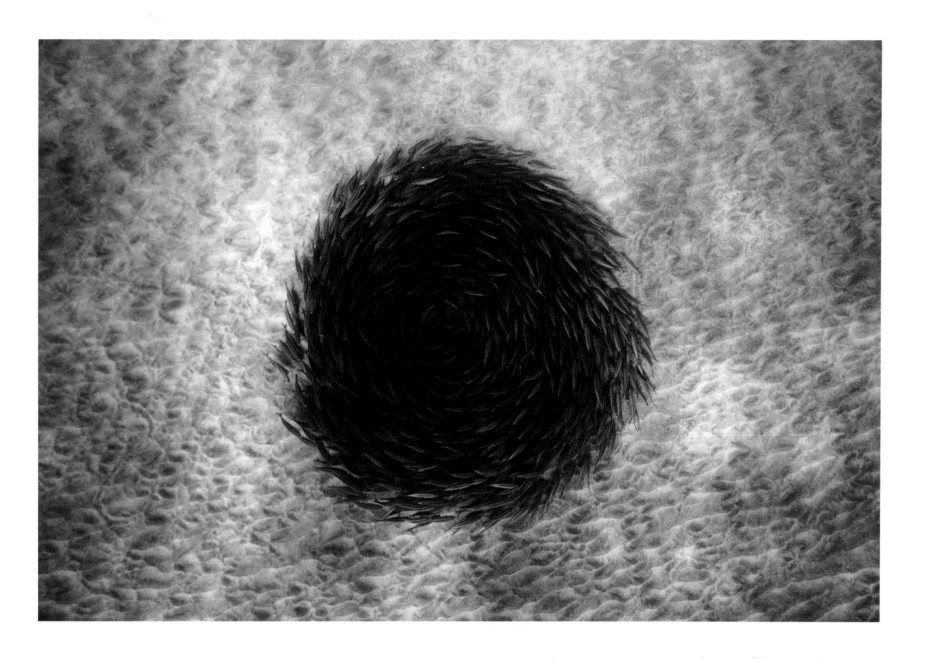

For Mel and Clare Levin
and for John Wrenn
W. L.

For BBE
T. F.

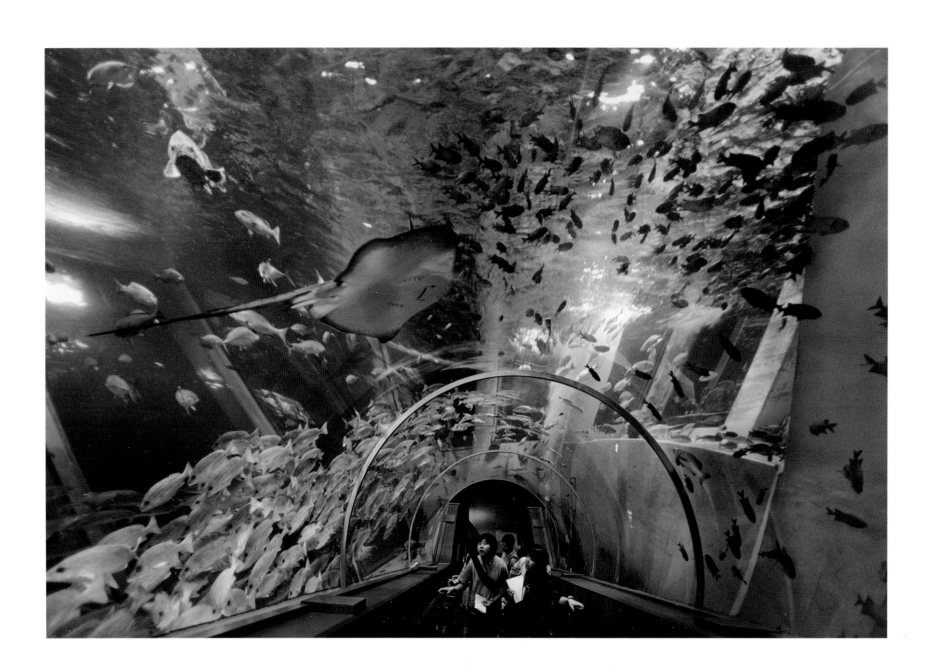

Contents

Introduction

Thomas Farber

For twenty-five years, photographer Wayne Levin has been creating ocean images: pods of dolphins; migrating humpback whales; "flying" body surfers within a breaking wave; gravesites of World War II battleships and planes; or very close to home, a tidepool water baby—his infant daughter. Though Levin has sailed on or immersed himself in tropic seas around our blue planet, much of his work has been achieved where he lives, on the Kona coast of the Big Island of Hawai'i. This photographer almost always alone on the face of the deep, free-diving with mask, fins, weight belt, and camera into bottomless depths. Then once again breaking the surface. Sun searing shoulders and neck, reflected light blinding as he scans the horizon for signs of life. Aqua deserta: away from the reefs, so much emptiness before such sudden, sometimes massive, presence.

Inevitably, during endless hours at the interface of sky and ocean, certain moments prove metaphoric. Several miles offshore, for instance, swimming toward a cluster of pilot whales. Great good fortune! But then a dorsal fin: an oceanic whitetip shark, known to be *very* aggressive. Or the kayaking photographer, dismayed to have miscalculated himself into a strong current, not sure he won't be swept into the winds and large swell of the 'Alenuihāhā Channel. This, when only minutes earlier he'd been submerged, hearing songs of migrating whales. Such moments are part of the photographer's relentless and usually solitary pursuit, always within the frame of surrender, the ocean more powerful than self, than art.

In 1997, Wayne's hunger to make representations of what he yearned to see in the ocean culminated in the award-winning book *Through a Liquid Mirror*. Several years before, he and I were on a magazine assignment to Cocos Island, an uninhabited marine preserve 300 miles west of Costa Rica's Pacific coast. There we witnessed rotating vortexes of thousands of fish, wheeling clusters of bodies and eyes; countless rays, wings rippling; and the squadrons of hammerhead sharks for which Cocos is notorious. In the disturbingly strong

currents and dizzying fecundity of these waters, diving with scuba gear three or more times a day in a kind of collective mania, we were perhaps as much a part of the underwater world as living humans get to be. Encountering hammerheads at eighty or ninety feet, we were just barely exempt from the inexorable logic of marine life. Big fish, little fish; the hunters and the hunted; the chase.

On the thirty-hour ocean passage back to Costa Rica, Cocos Island transformed into memory as dolphins surfed the bow wave. Our captain altered course to skirt vast long-line nets. Commercial and sports fishing are banned at Cocos, but poaching continues. And even if Cocos were protected, would it soon be little more than a living diorama? Cetacean specialist Roger Payne was at this time arguing that large marine creatures will die off, poisoned by chemicals. And oceanographer Sylvia Earle was warning that we're over-harvesting fish to the point of extinction. Returning from Cocos' miracles, then, Wayne and I were left with a sense of overwhelming man-made change, of impending loss.

What should one, can one, accommodate? Artists are often drawn to what's ambiguous. Not long after the Cocos trip, back in Hawaiʻi, I visited a hotel that keeps dolphins in a small lagoon by the ocean. So near, and yet so far. The dolphins were extraordinary; to observe them at close range, and from terra firma, was amazing. But in what context? Something to do with dollars—dolphins connected to display cases of Native Hawaiian antiquities, Italian marble countertops, singers in the lounge. And what could any person bring to this encounter with such marvelous beings? Receptivity? Sympathy? This particular day the Nasdaq was again soaring. Many hotel guests, amiably overweight, lounged in thick terrycloth robes. Little question of which species was at the top of the food chain.

At the hotel that afternoon, I thought about a dolphin research facility several miles away. Its goal, understanding the world through scientific method; impulse to proof, the replicable. Teaching dolphins to "speak." To us, that is to say. The director of the facility using the possessive: "my dolphins."

How do we approach, construe, the Other? As Gavan Daws writes, evolution in the water world has evolved "a distribution and processing of sensory information so unfamiliar to humans that we have no way of bringing it together to make it spell consciousness, at least in our spelling: oceanic change of temperature, light, color, barometric pressure, chemical and nutritive composition, acidity and salinity of water, and—on

a cosmic scale—the pull of the sun, moon, and stars, the turning of the earth, acting on the massive ocean currents and running the tides."

In this post-Cocos period, Wayne and I went to see a traveling exhibit—LIVE SHARK SHOW—at the Hawai'i State Fair. Ferris wheels with flashing bulbs, food stands, a roller coaster, bungee jumpers. The audience at the shark show was enthusiastic and curious, parents and children alike, but the tank—it seemed to be a sixteen-wheeler's trailer with one viewing wall—had the air of close confinement, the tawdry. At Cocos, Wayne and I had witnessed the phenomenal speed at which skittish hammerheads could disappear. And, one understood, *reappear*. Here the sharks had, literally, nowhere to go.

This book began in part out of apprehension: a sense that the ocean's dying because of us; that aquariums will be the repository of what remains, the oceans of the future.

To live is to experience fear, but also to see the proverbial glass as half full. In his travels to twenty-three aquariums in the United States and Japan, Wayne sought to understand and depict our complex relationship with captive marine life: aquariums as marvels of technology; human desire for contact with other species; our impulse to educate; our capacity to contain, dominate. In these aquarium voyages, however, sometimes accompanied by his daughter Elise, Wayne was also savoring. He's always enjoyed, say, Disneyland, been intrigued by display cases, shop windows. Reflections, refractions. Doublings, mirrorings. It should also be noted that Wayne is an omnivore. He eats meat and fish. Loves sushi. With this mix of emotions, perspectives, and appetites, then, Wayne journeyed far and wide to other oceans.

In the book of Job, as Stephen Mitchell renders it, the Creator "stopped the waters,/as they issued gushing from the womb," then "closed it in with barriers and set its boundaries." This was when "the morning stars burst out singing/and the angels shouted for joy."

How did aquariums begin? As early as two millenia B.C.E., Sumerians kept fish in man-made ponds. And centuries ago, Native Hawaiians were practicing aquaculture in enormous enclosures adjoining the ocean. By the mid-nineteenth century, the first public aquarium opened in England. Soon after, P. T. Barnum, legendary circus entrepreneur, put living aquatic animals on display and sold tickets to the American public.

3

The age of aquariums. In Portugal, the Oceanario (construction cost: $70 million) attracted nine million people during its first few months of operation. Japan's Kaiyukan Aquarium (construction cost: $107 million) draws four million visitors a year. And in Italy, only the Sistine Chapel and Pompeii have more visitors than the Genoa Aquarium.

Needless to say, these three water worlds did not invent themselves. Their creator was Boston architect Peter Chermayeff, who sees them as a theater where people can gaze at and dream about other forms of life. Chermayeff well understands, however, that his aquariums are not an accurate representation of nature (as if any representation can be "accurate," or more than a simulacrum). Still, he hopes to encourage an environmental ethic, "to make amphibians" of visitors. As for economics, though many of Chermayeff's creations were designed as nonprofits, they are, as he puts it, "very good business."

Some psychologists argue that water represents the unconscious, is a seductive regression to the instinctive. In Stanislaw Lem's novel *Solaris,* the ocean is sentient, capable of diagnosing the hearts of visiting scientists, creating for them incarnations of their own yearnings.

What, one might ask, do these other oceans show us about ourselves?

A sea dragon swims in the Waikīkī Aquarium, pectoral and dorsal fins vibrating. Full grown at twenty inches in length, it looks like a sea horse transformed by Ovid, having sprouted branches and leaves. What kind of story, scientific or otherwise, can explain such an enchanting creature?

Near the sea dragon, there's a large tank: leopard shark, ray, jacks, trevally, all slowly circling, circling. A large grouper hangs motionless by the glass, its eye on mine. Neither of us blinking.

Visitors stand in front of the tank, one member of a couple taking a picture of the other, then roles reversing. The grouper hanging, staring.

Realities.

Once, I said to Wayne, "If I had to bet, I'd guess very few people have drowned in an aquarium."

"Or been eaten by a photograph," he replied.

The stories aquariums tell are not all the same. At the Monterey Bay Aquarium website, we read that they "envision a world in which the oceans are healthy, and people are committed to protecting the integrity of Earth's natural systems. . . . Stewardship begins with inspiration, and we offer enjoyable and enlightening experiences to inspire a love and understanding of nature." Fair enough, one thinks. Grandiloquent, but high-minded.

At the Oregon Coast Aquarium website, which has "live shark cams," we learn there's a 112-foot acrylic tunnel. Visitors can "stroll straight into the deep, cold sea without getting wet." No worse than an enthusiast's hyperbole, this phrase, but still giving one pause.

Stories aquariums tell and stories told about them. One aquarium, I learn, began with a killer whale; the aquarium was built around it. After protests and eco-sabotage, however, the aquarium announced that this would be the last killer whale it would keep captive.

High-minded, enthusiastic, conflicted: our human endeavors, our psyches, are all of these.

On the Cocos Island trip, nearly every diver carried expensive cameras, most costing thousands of dollars. There was a darkroom on board, film developed overnight, and video could be screened immediately. Instant metacommunication, a viewing of images of what we saw to . . . see what we saw? At times, the images themselves appeared to be the goal. Being in nature at Cocos was thus inextricably intertwined with recording experience, something I noted on one of my many trips below deck to turn on my computer, composing a version of our voyage, afraid of "losing" it.

In the aquariums, a visitor realizes, the eye is frequently compelled by yet another screen, model, picture, or digital image. As if life itself cannot measure up to our representations of it. But can you just "take something in"? Is there such a state of being? Are our stories and images not also miraculous? Is there an "us" without them?

Whale sharks are the world's largest fish, up to seventy feet long. Wayne and I planned a trip to Perth, Australia. If you want to swim with whale sharks, you take a jumbo jet to Perth. A spotter plane does the locat-

ing, a small boat then speeding you to the rendezvous, dropping you overboard. High-tech fossil-fuel-munching eco-journalism, like some of our other trips. But this one, we rued, never quite happened.

There's a whale shark in the Osaka Aquarium. "I saw the whale shark," Wayne said on his return from Japan, "but I don't really count it as having seen one."

The verb "behold," from Middle English: to hold, have in sight, keep. Now meaning to observe, look upon, consider. There's also "beholden": bound in gratitude, indebted.

What Wayne Levin's beheld. What he's beholden to. Back home from aquarium travels, he goes out for yet another long swim in Kealakekua Bay. Mask, flippers, Nikonos camera. He comes across a huge school of *akule*—bigeye scad. A million fish. Millions? Moving, it seems, as a single being, this teeming mass of protoplasm rotating, pinwheeling, spiraling in on itself—themselves. Creating a form that is primary, rudimentary, breathtaking, essential.

Think, say, solar system. Think: beginning. Think: world without end?

primal sea

Kelp forest, Monterey, California

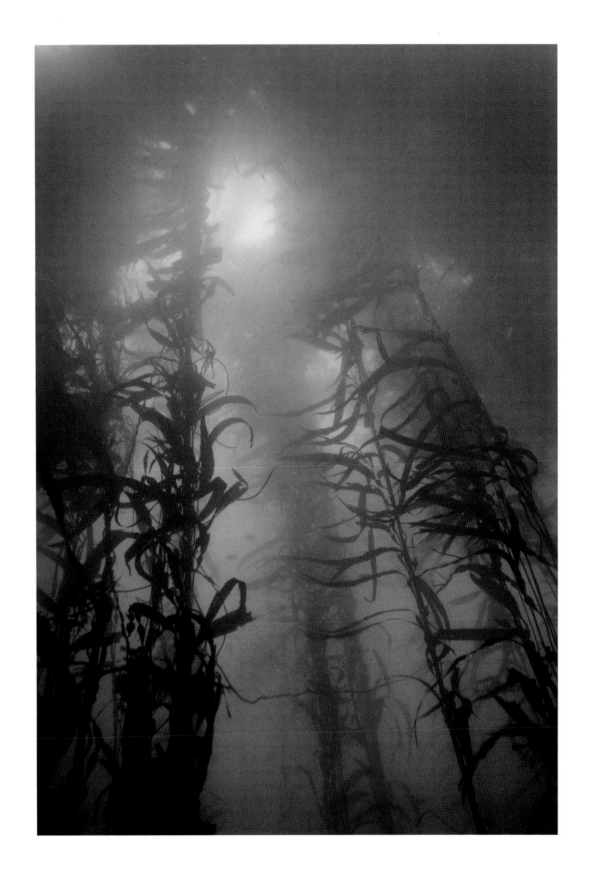

Deep ocean sea urchin, Hawai'i

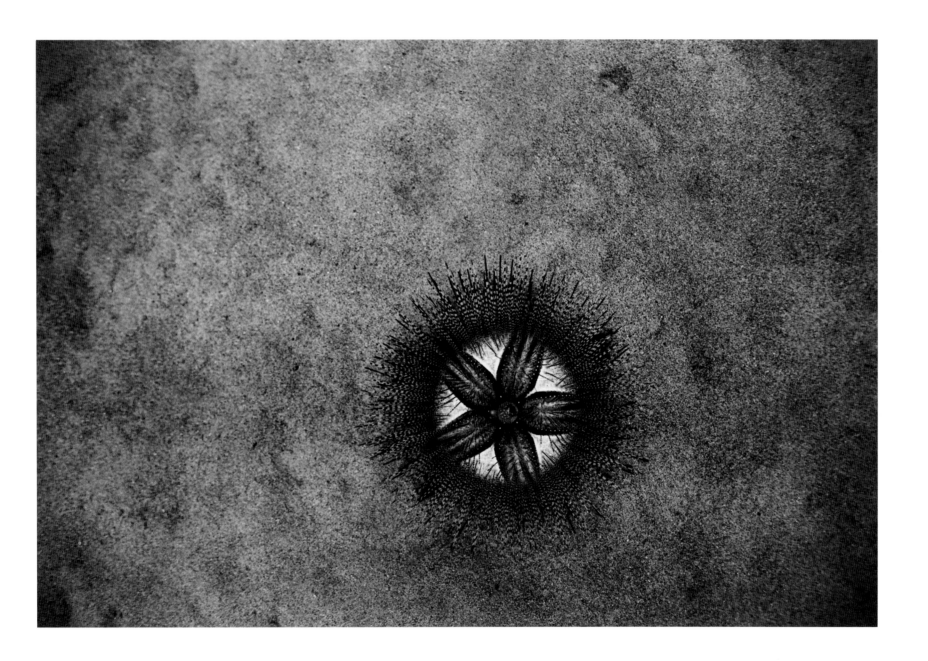

Green sea turtle, Hawai'i

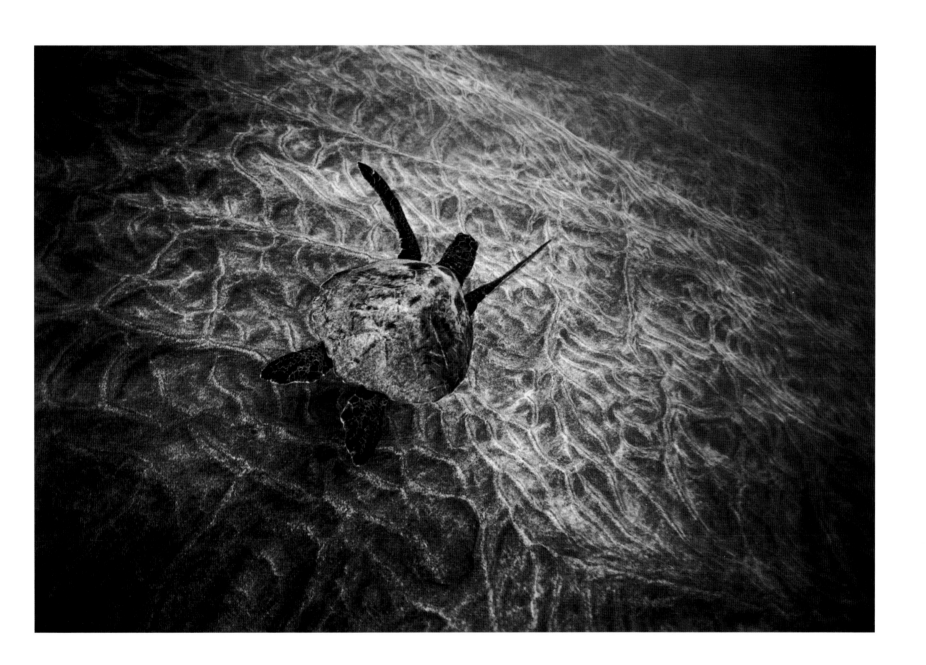

Goatfishes, Hawai'i

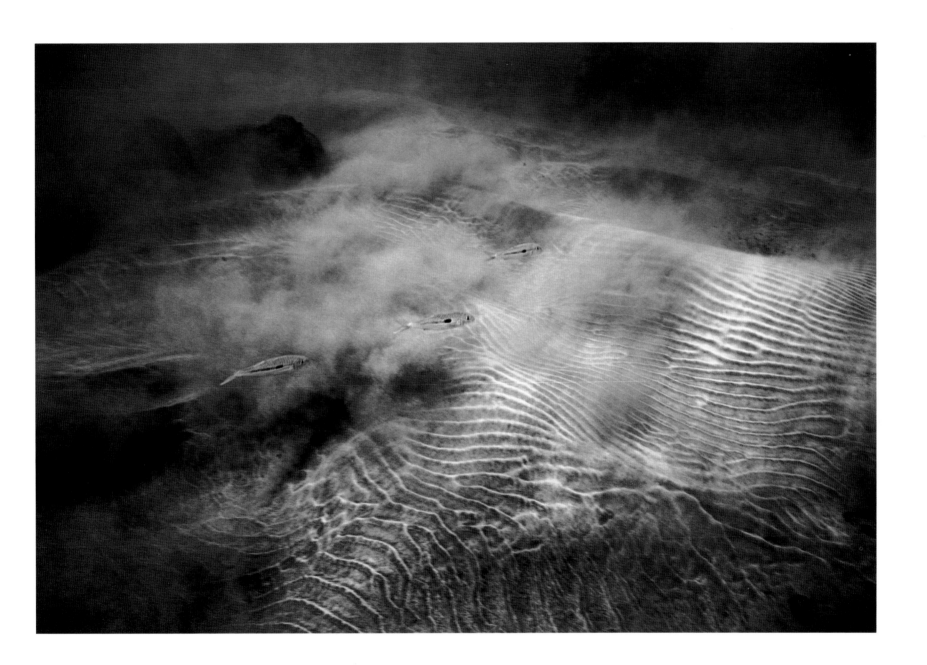

Convict tangs, Midway Atoll

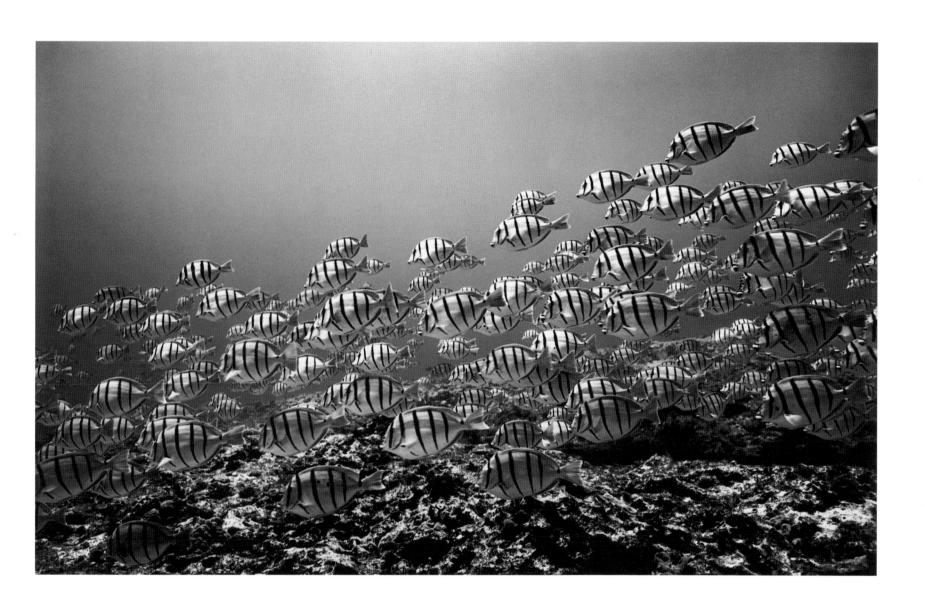

18 *Heller's barracudas, Hawai'i*

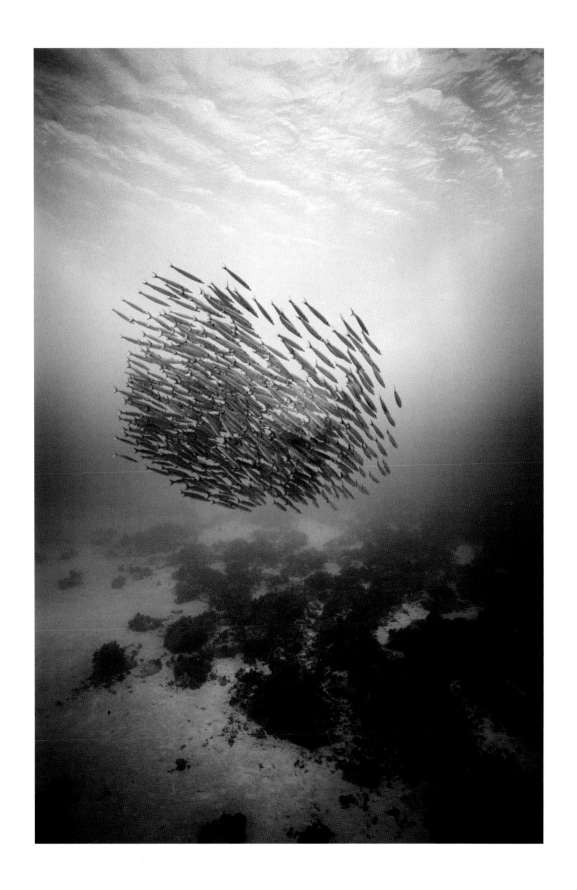

Column of akule, Hawai'i

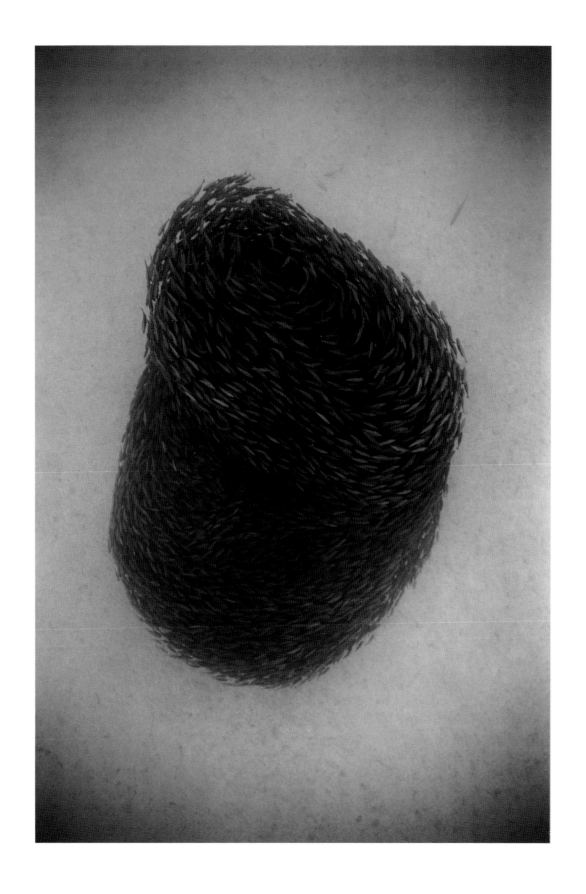

22 *School of* akule, *Hawaiʻi*

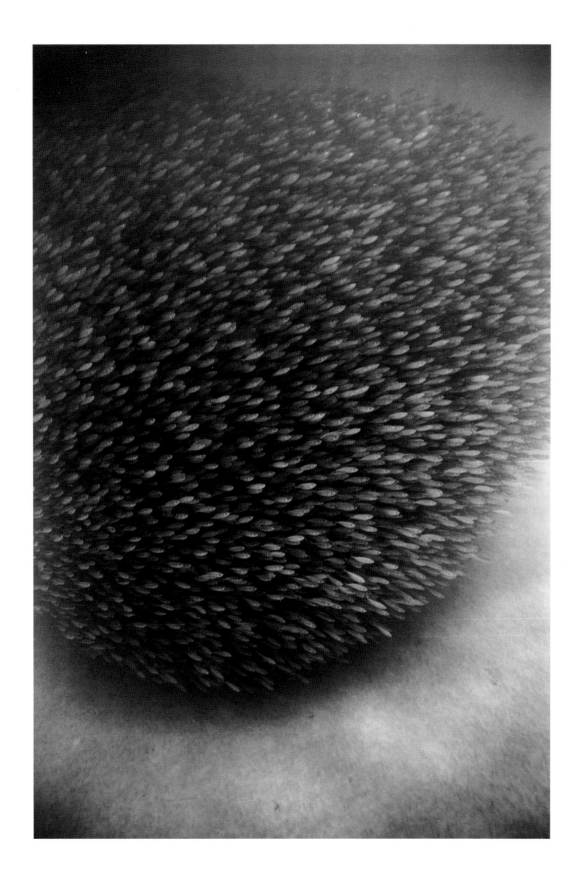

In a school of akule, Hawai'i

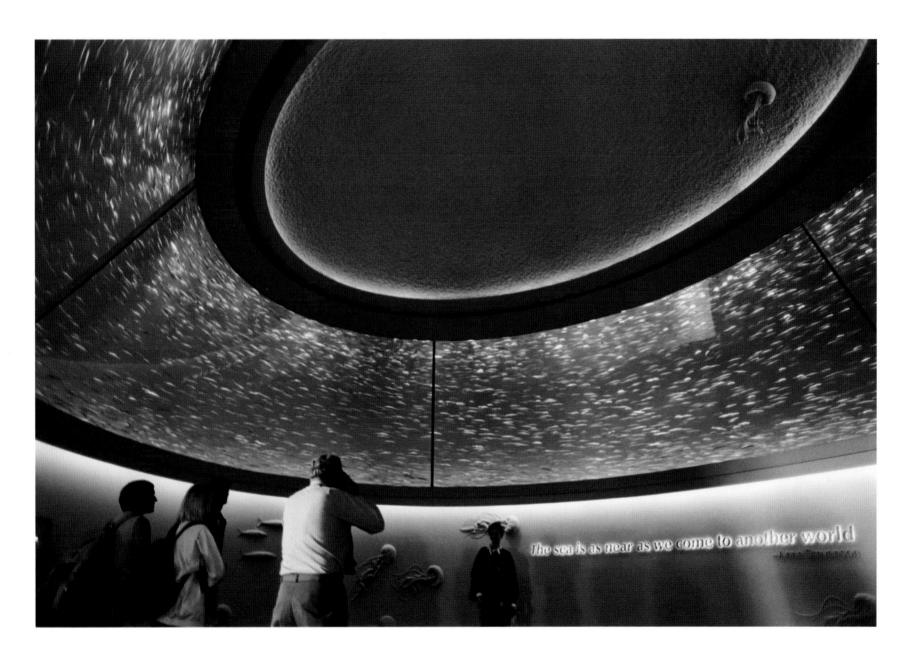

The sea is as near as we come to another world

Monterey Bay Aquarium, California

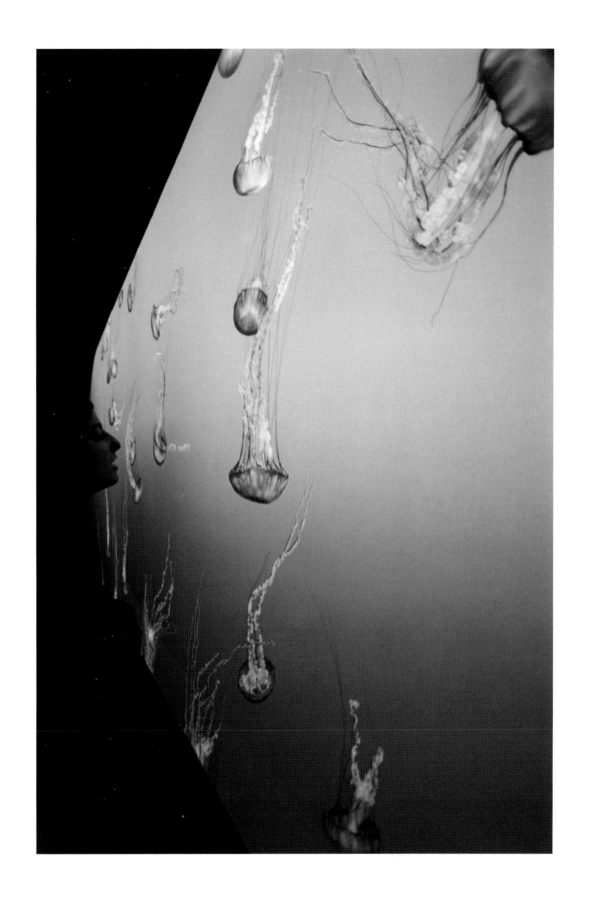

32

Tokyo Sea Life Park, Japan

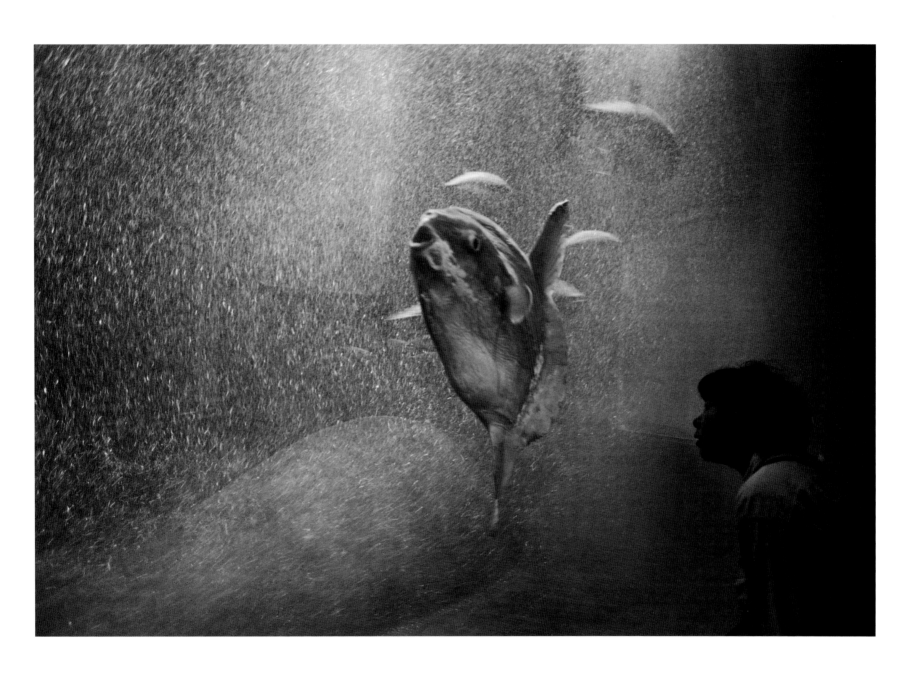

34 *Hakejima Sea Paradise, Yokohama, Japan*

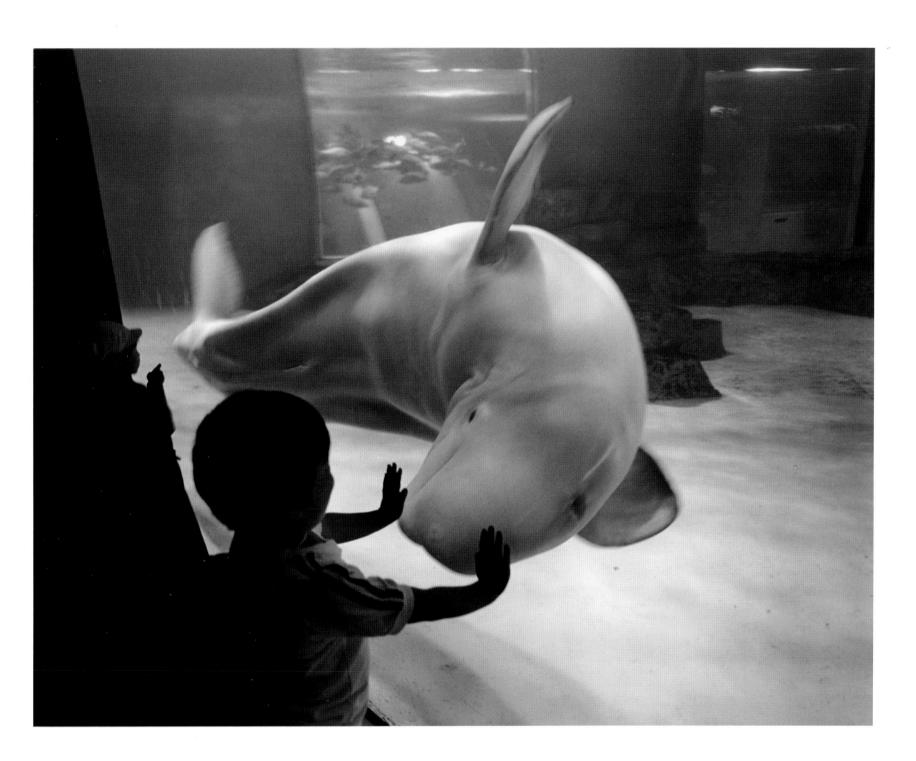

Shinagawa Aquarium, Tokyo, Japan

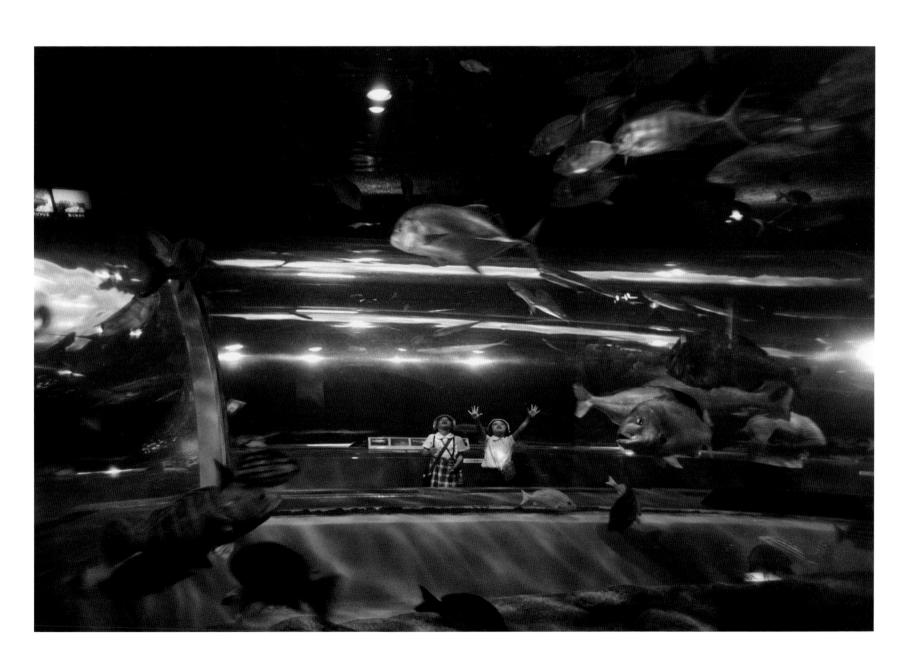

Hakejima Sea Paradise, Yokohama, Japan

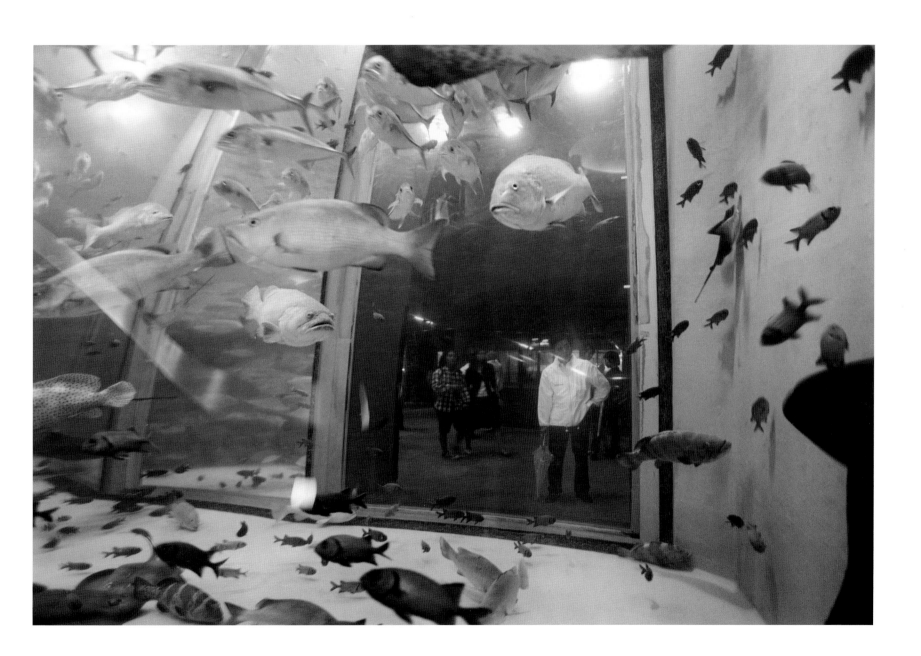

40 *Aquarium of the Pacific, Long Beach, California*

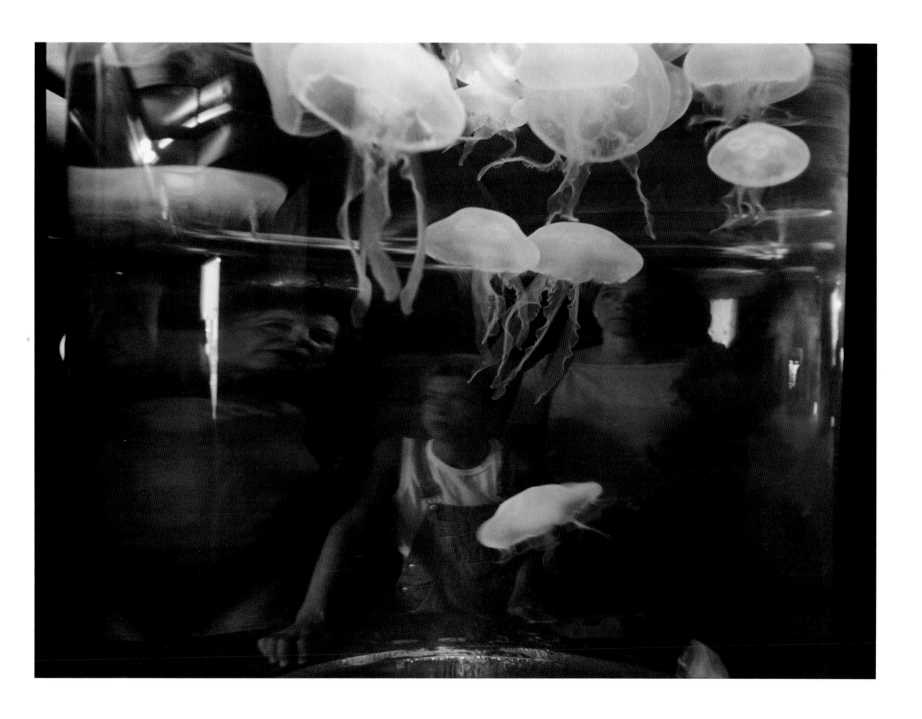

Kaiyukan Aquarium, Osaka, Japan

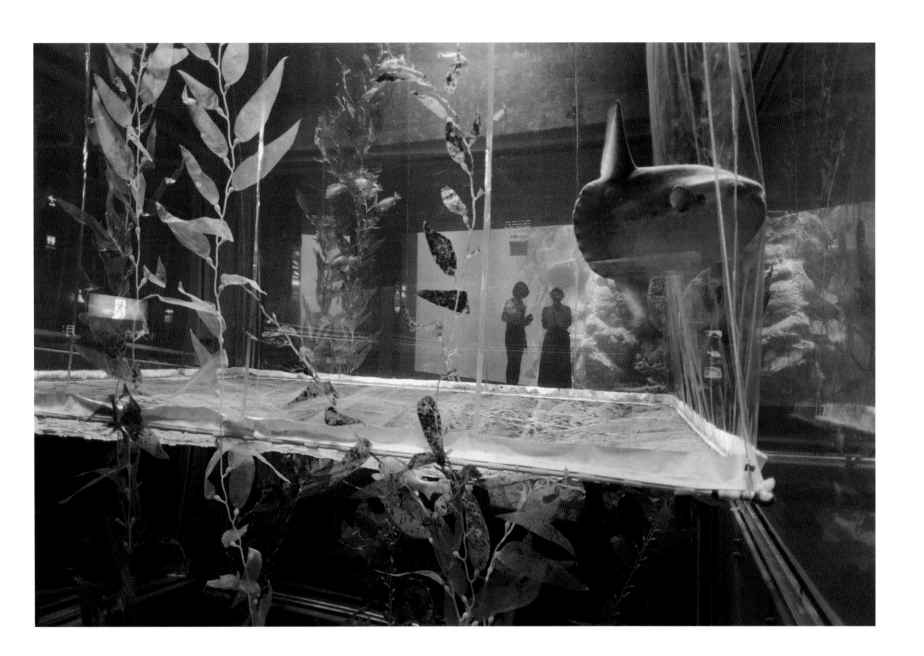

Aquarium of the Pacific, Long Beach, California

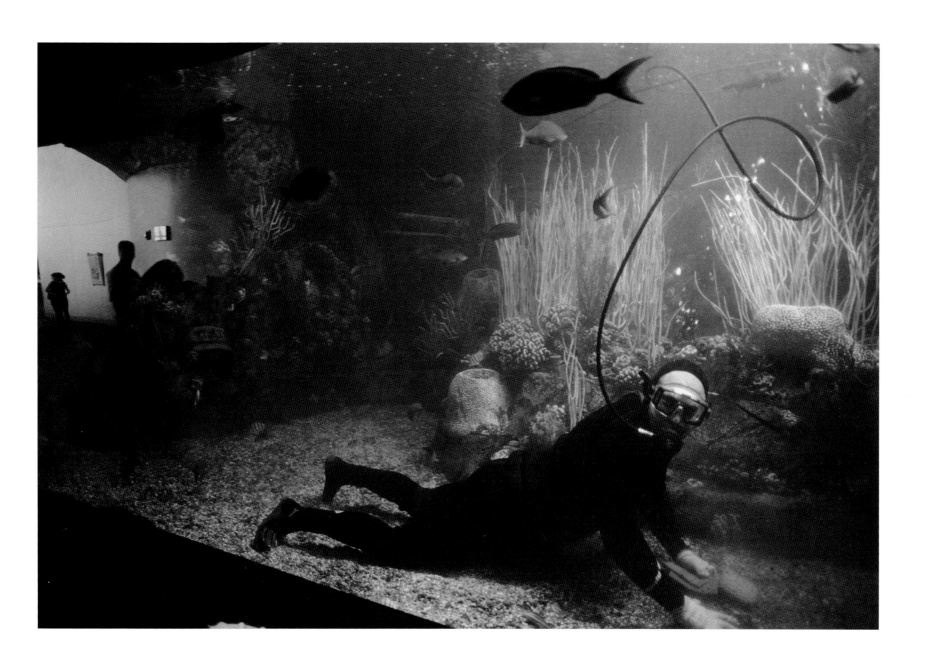

Steinhart Aquarium, San Francisco, California

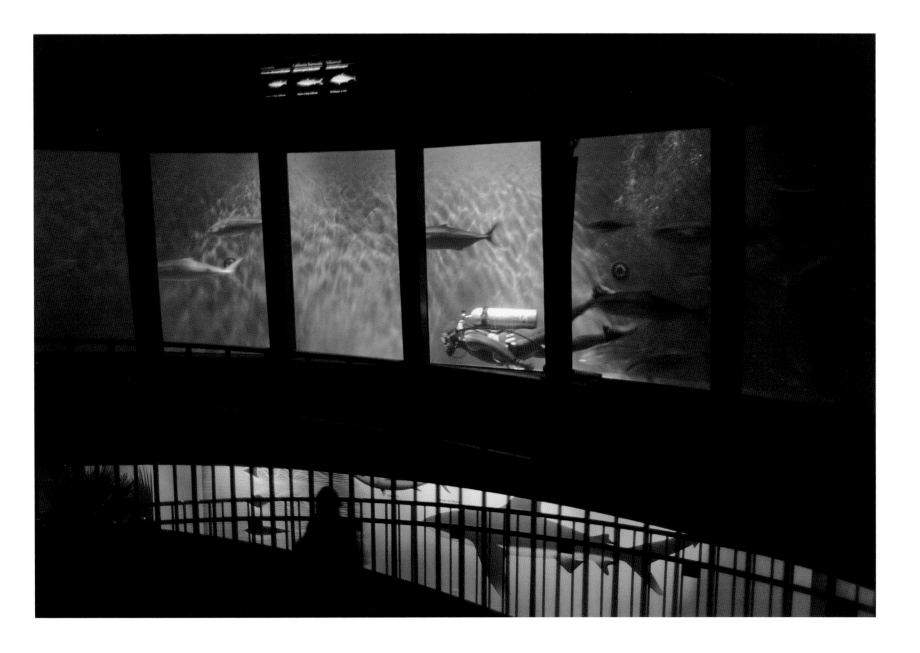

48 *Kaiyukan Aquarium, Osaka, Japan*

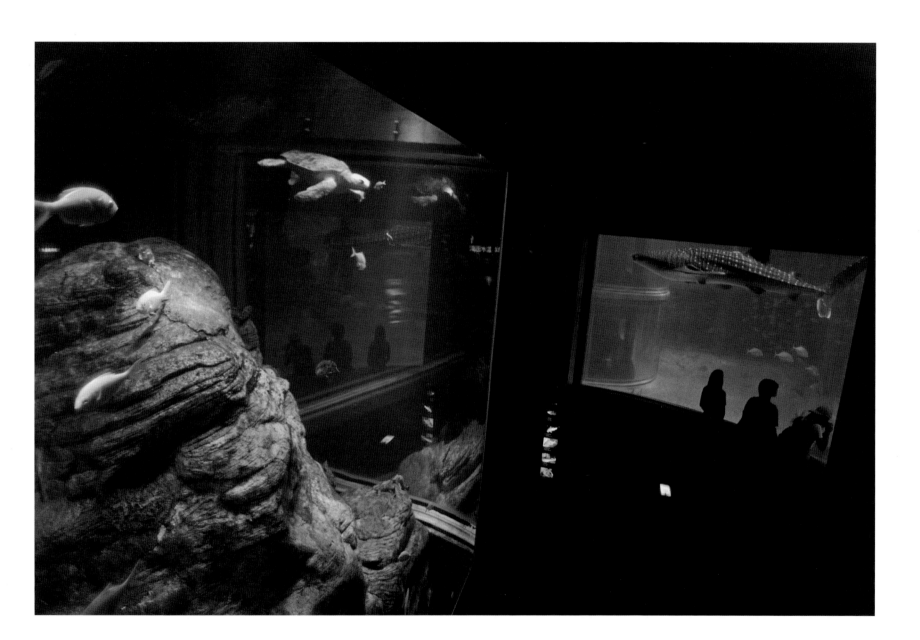

Hakejima Sea Paradise, Yokohama, Japan

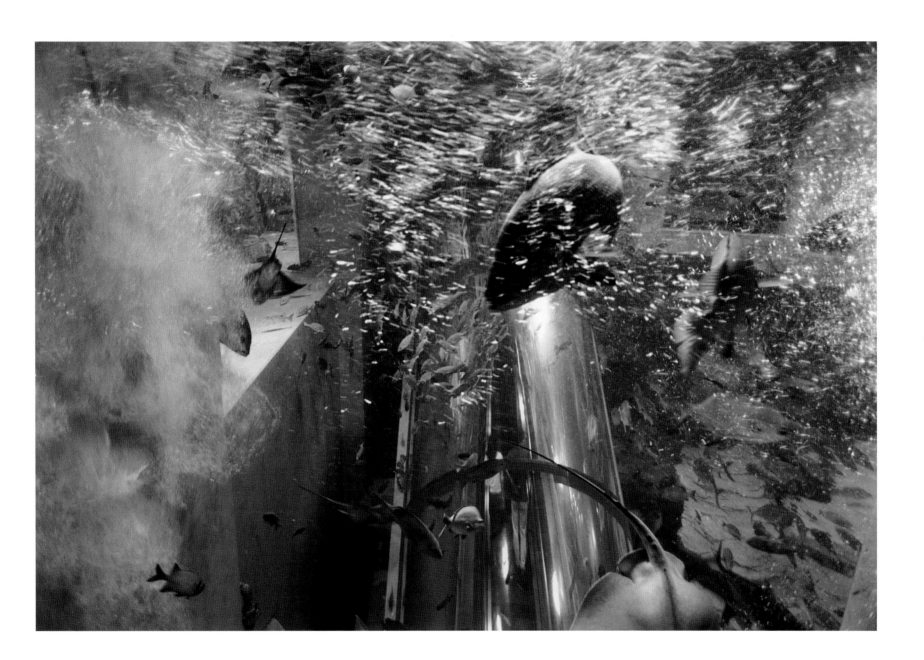

Maui Ocean Center, Hawai'i

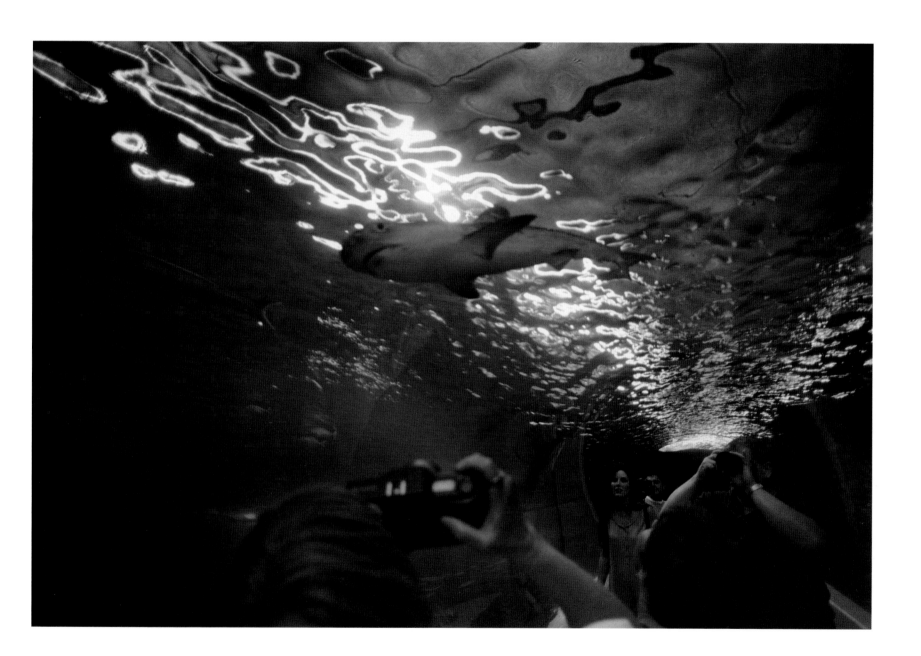

Enoshima Aquarium, Japan

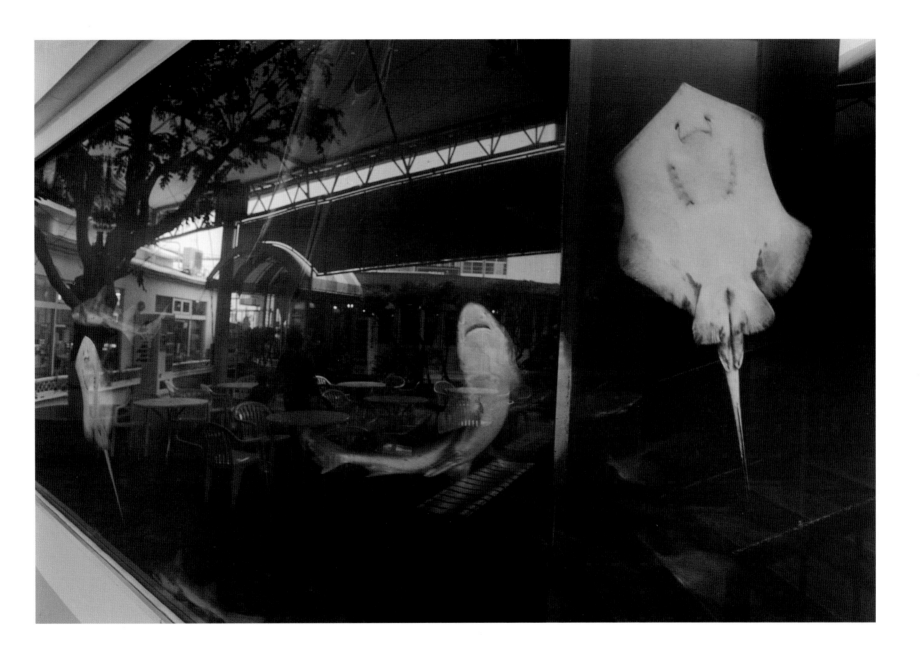

Kaiyukan Aquarium, Osaka, Japan

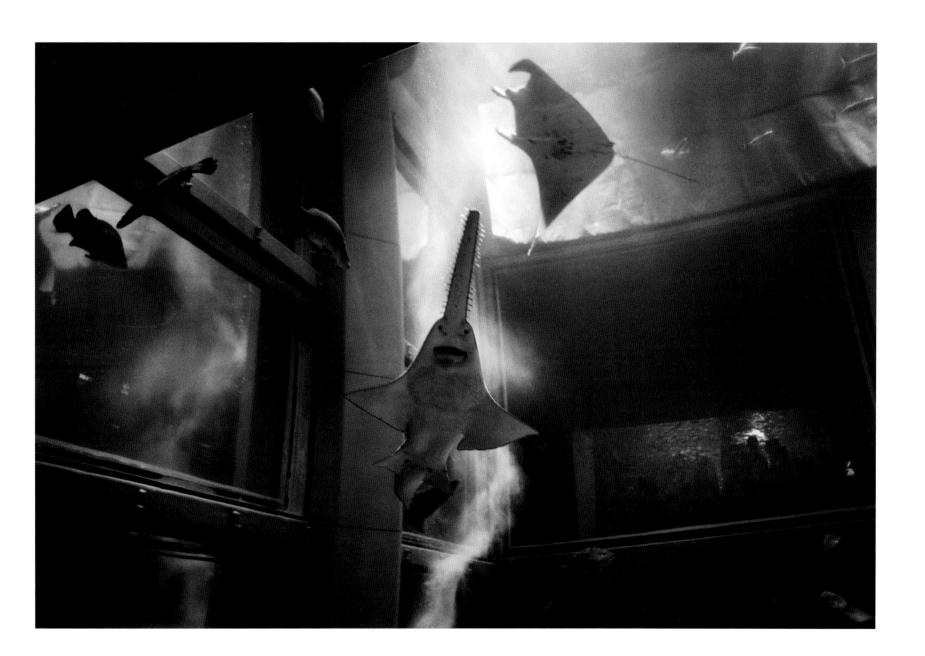

UnderWater World Aquarium,
Fisherman's Wharf, San Francisco, California

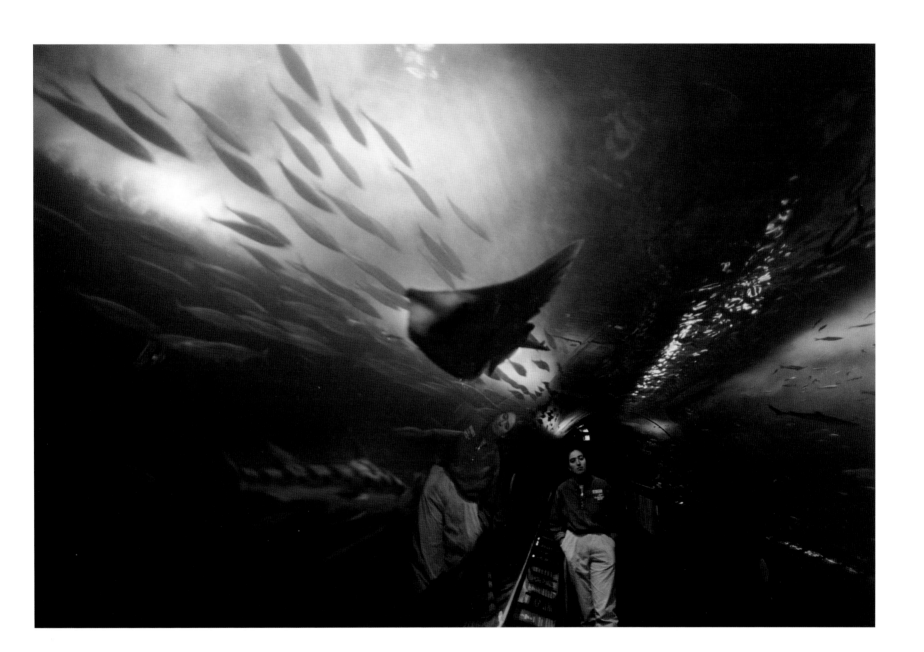

Hakejima Sea Paradise, Yokohama, Japan

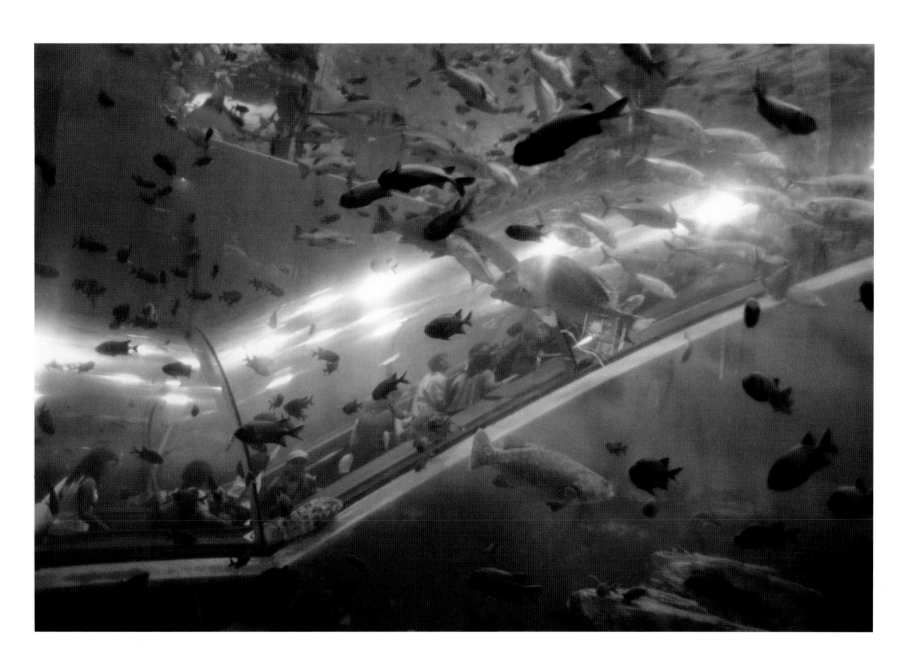

Maui Ocean Center, Hawai'i

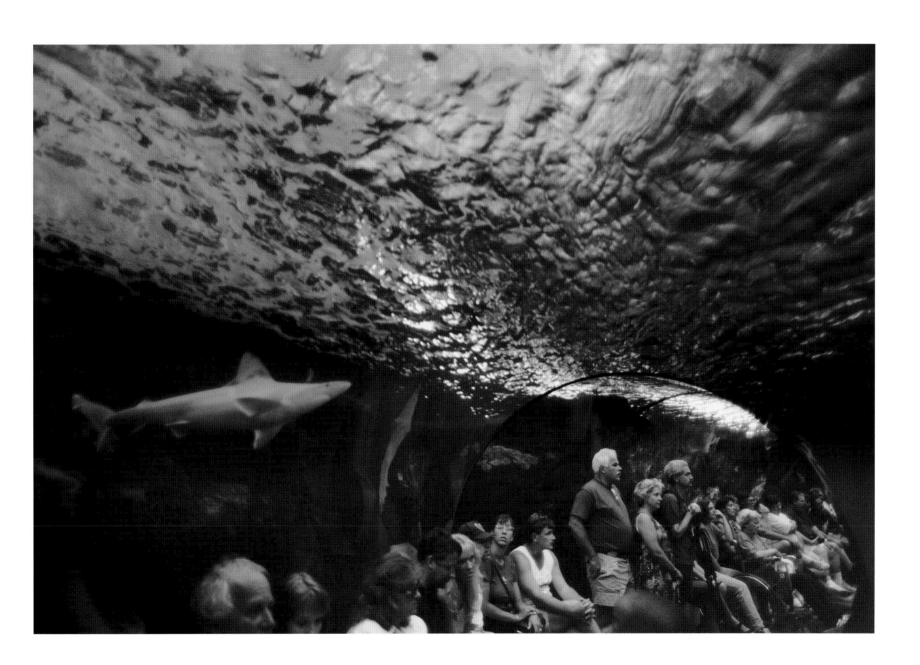

Kushimoto Aquarium, Japan

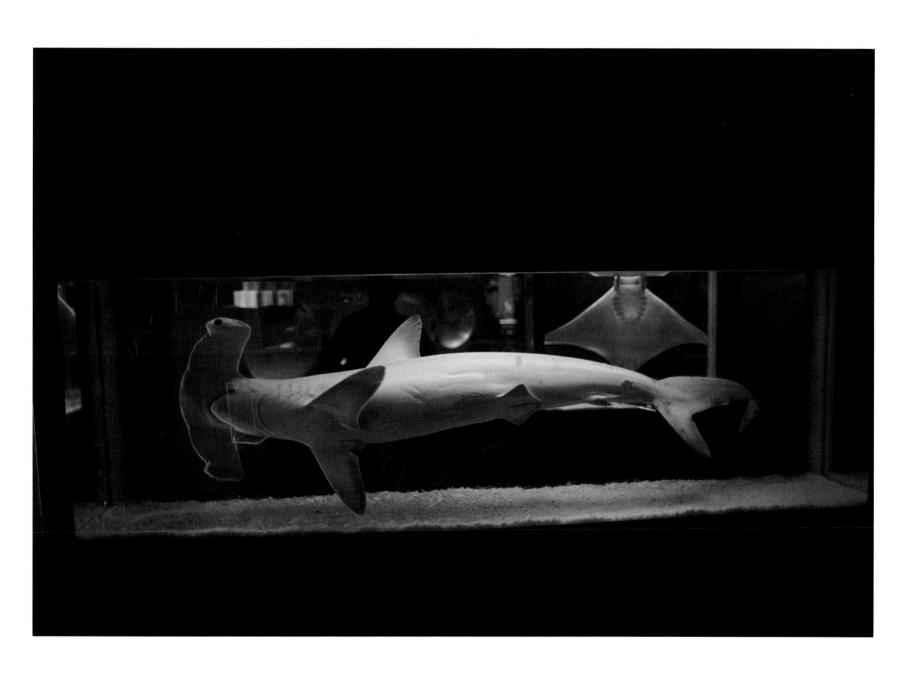

Sea World, San Diego, California

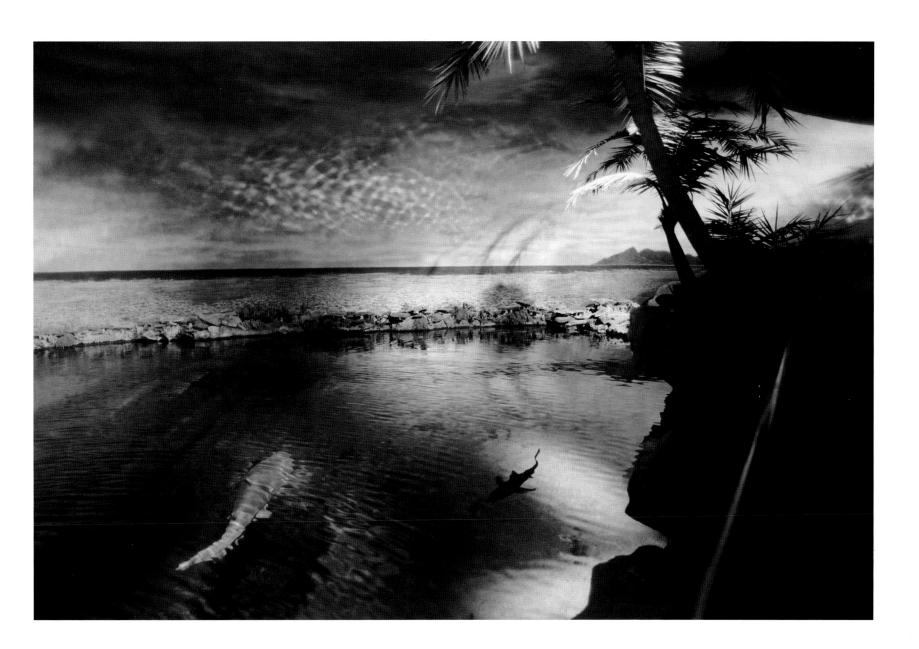

Kaiyukan Aquarium, Osaka, Japan

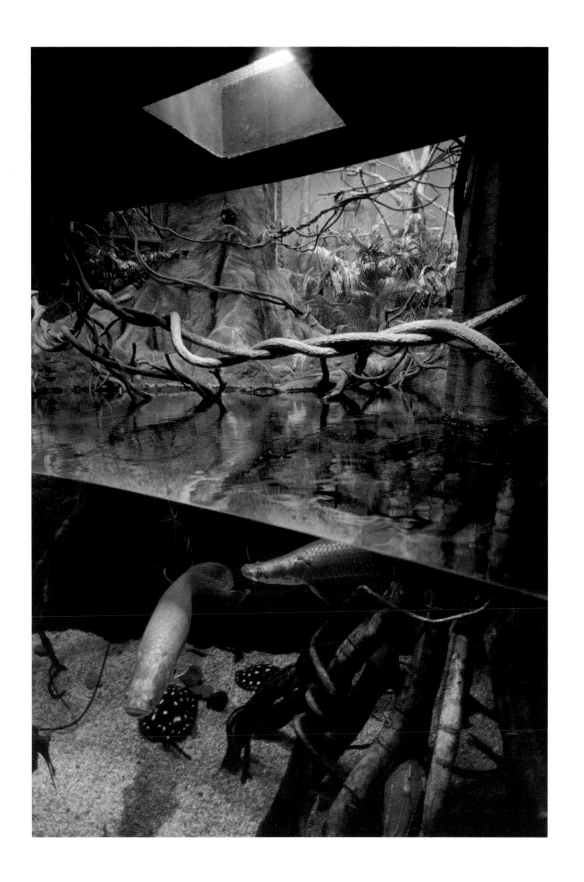

Aquarium of the Pacific, Long Beach, California

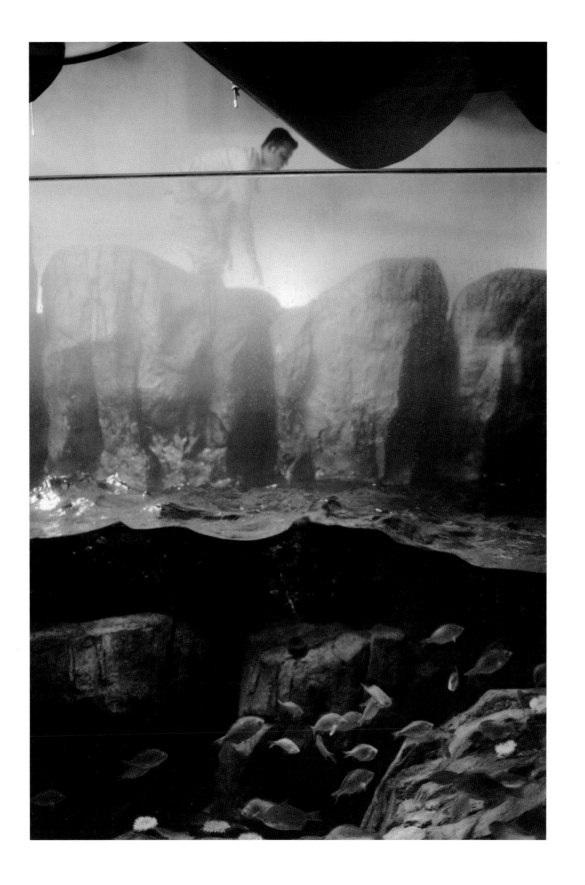

Aquarium of the Pacific, Long Beach, California

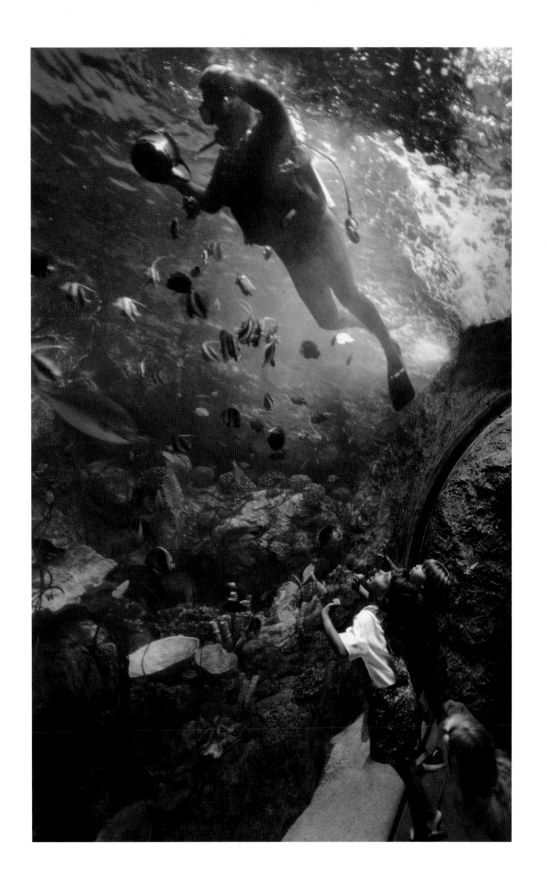

74 *Toba Aquarium, Japan*

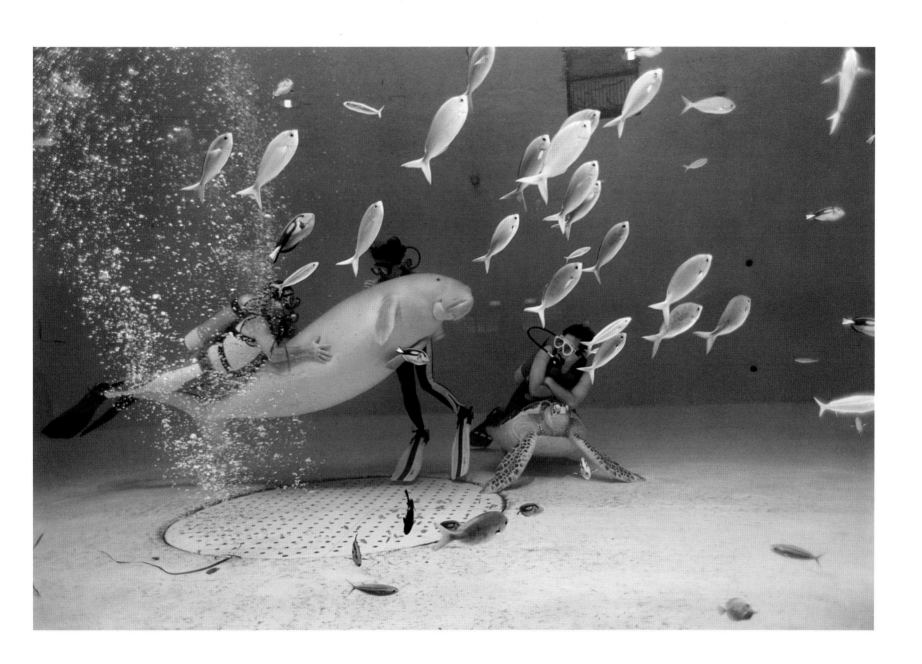

Shinagawa Aquarium, Tokyo, Japan

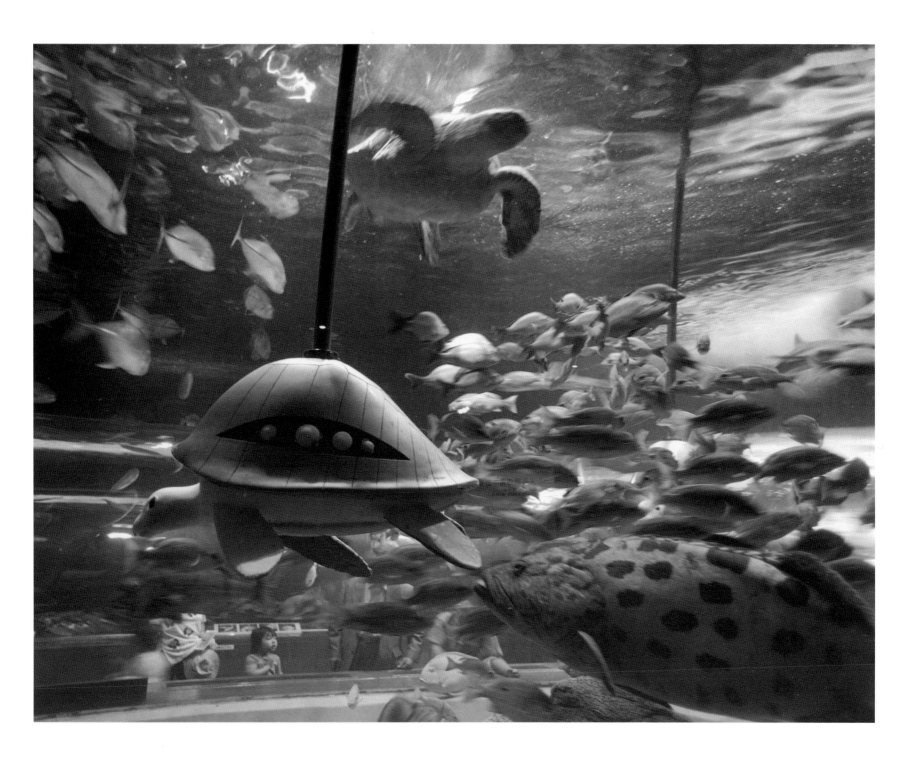

Suma Aquarium, Kobe, Japan

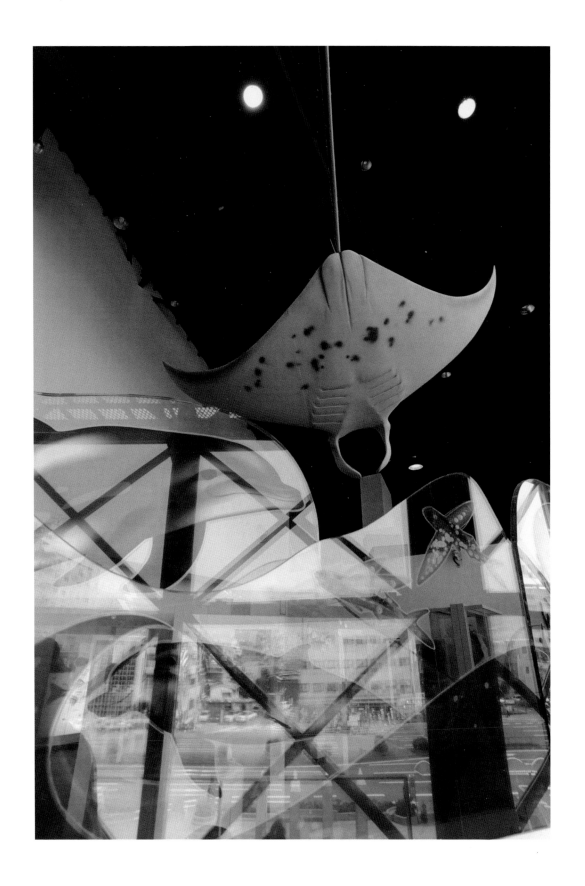

Aquarium of the Pacific, Long Beach, California

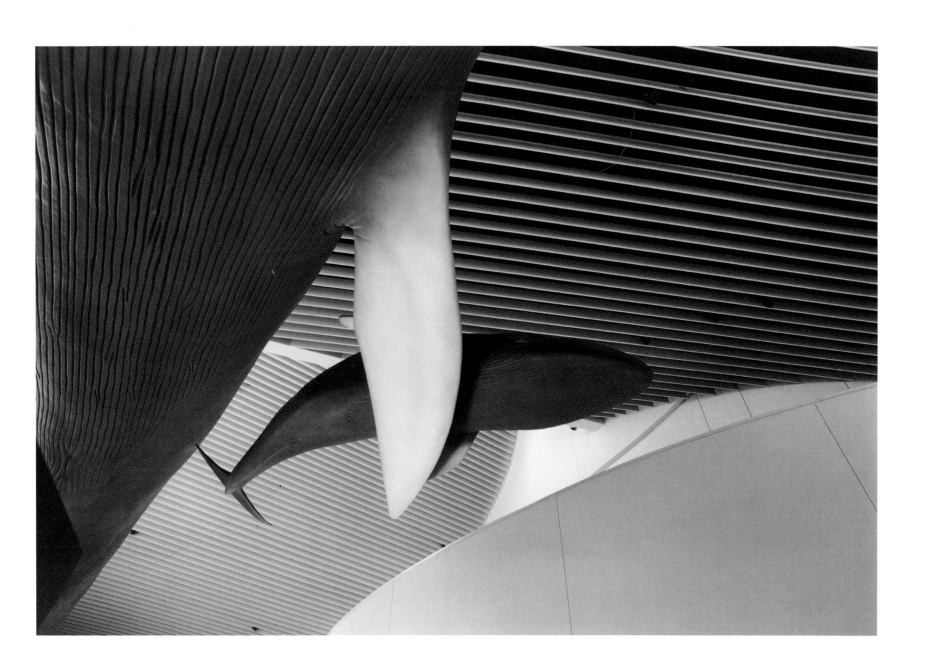

Sea World, San Diego, California

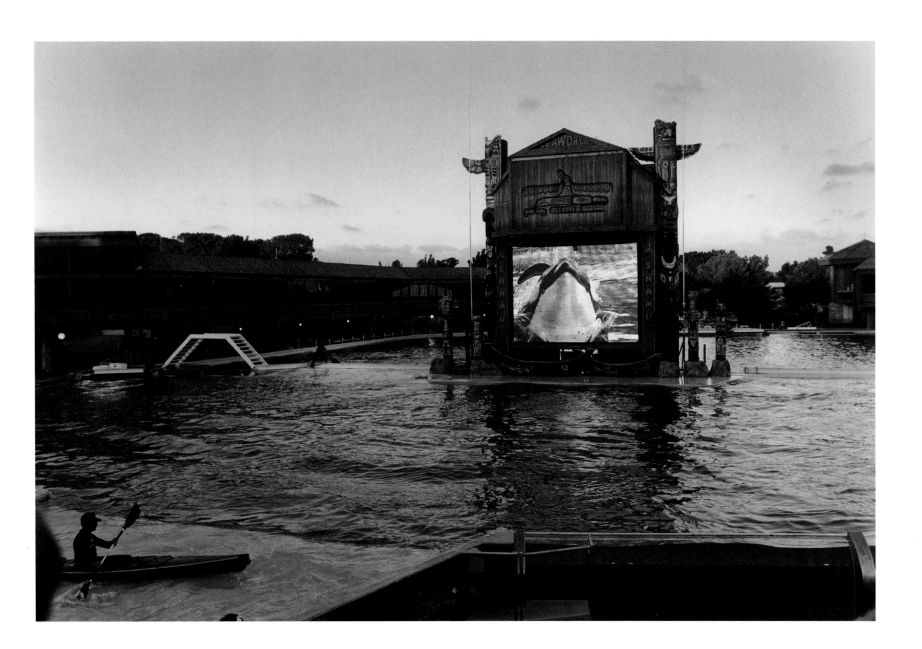

Hakejima Sea Paradise, Yokohama, Japan

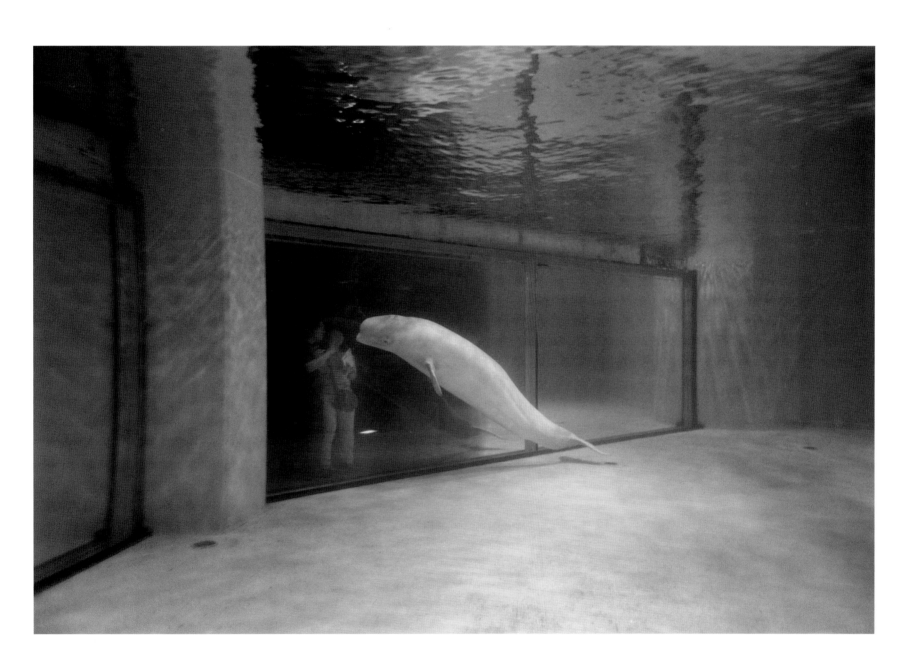

endless sea

Pilot whales, Hawai'i

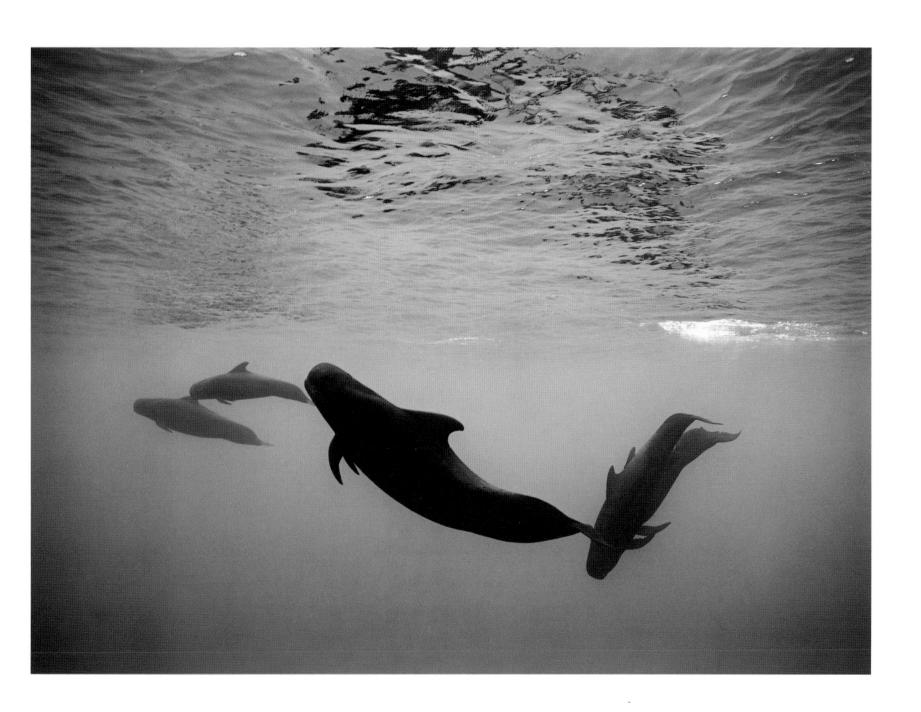

Spinner dolphins, Hawai'i

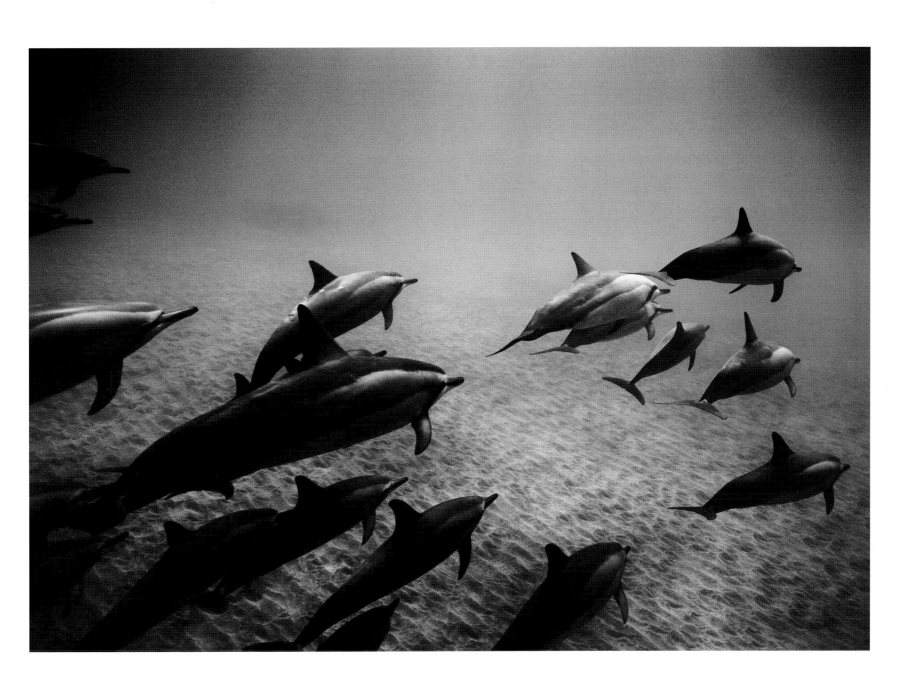

Spotted dolphins, Hawai'i

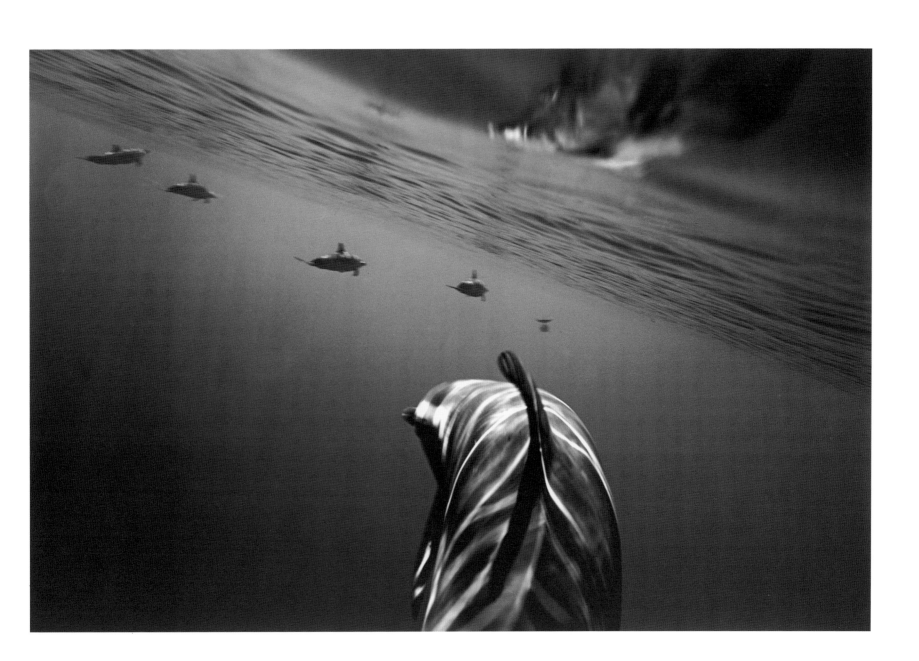

94 *Oceanic whitetip shark and pilot whales, Hawaiʻi*

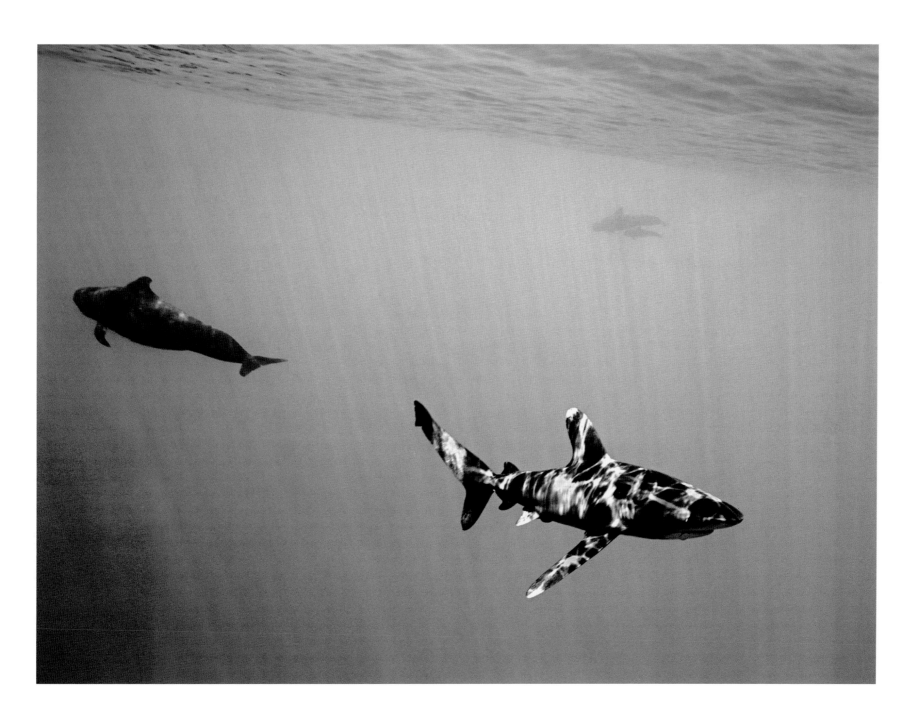

California sea lion, Santa Barbara Island, California

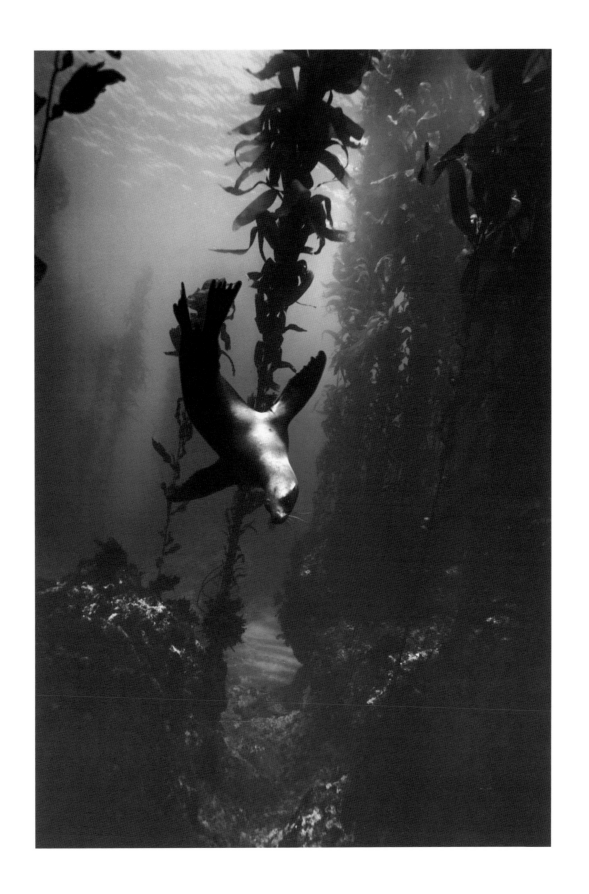

Shipwreck with goatfishes, Midway Atoll

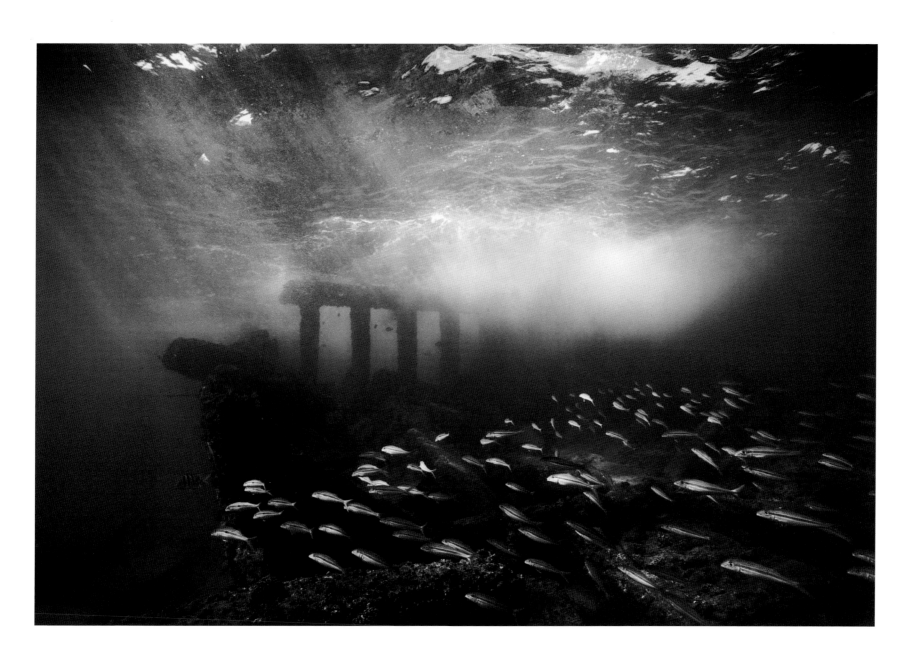

Green sea turtle under pier, Midway Atoll

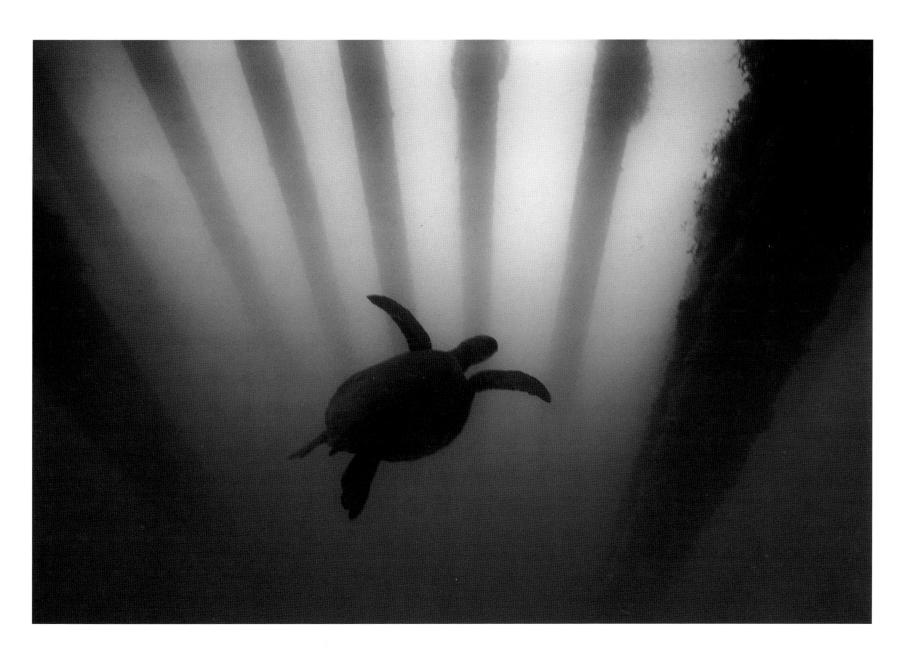

Aquariums

Bruce A. Carlson

One reason so many of us delight in aquariums, be they large or small, in the living room or in a public building, is the great enjoyment they offer for so little effort—we have only to open our eyes! Everyone loves to watch fish swimming in an aquarium; it's relaxing, and some claim it's even therapeutic. Next to photography, keeping aquariums is the second most popular hobby in the United States. Building upon that popularity, large public aquariums have become major attractions, where people go to see sharks, colorful fishes, unusual animals like jellies and octopuses, even dolphins and whales.

All public aquariums and aquatic theme parks work to create memorable experiences for visitors, but in recent years their mission has become much more than mere entertainment. A sea lion balancing a ball on its nose may be a crowd-pleaser, but aquarium professionals recognize a higher purpose for aquatic displays. They strive to create exhibits that inspire, that create a sense of wonder, and that raise awareness and increase understanding of our relationship to freshwater and marine ecosystems. Aquatic animals and plants are now presented in exhibits that more closely simulate their natural habitats, at once providing a more authentic experience for the visitor and superior living conditions for the organisms displayed. Such exhibits provide opportunities for contemplation and, ultimately, the realization that astonishing underwater realms exist apart from our ordinary reality.

Modern aquarium displays are difficult and expensive to create compared to old-fashioned painted concrete tanks filled with water and a few rocks. A successful exhibit is the result of careful planning and painstaking attention to detail, often requiring the development of sophisticated life support systems. The best exhibit designers are also artists—people who inspire us through their vision and creative interpretation of the underwater realm. Just as a photographer captures images of the world through the lens of the cam-

era, an exhibit designer must capture the essence of an aquatic habitat behind the window of the aquarium. If successful, such an aquarium can produce life-long changes in the attitudes and behavior of its visitors.

Not every aquarium is effective, and some may even provoke a negative response. Exhibits fail when visitors feel uncomfortable watching animals in inappropriate surroundings or behaving unnaturally. Most aquarists, however, work hard to create suitable environments for the animals in their care and endeavor to develop displays that increase understanding and appreciation of aquatic life. A talented aquarist can take even the most mundane organism and create an exhibit with as much impact on the viewer as a shark tank. Impossible? Consider the kelp forest exhibit at the Monterey Bay Aquarium. Among the finest aquarium displays ever created, the featured organism is a brown alga!

Now that we have entered a new millennium, what can we expect to see in the next generation of aquarium exhibits and programs? During the last century, aquariums evolved from simple aquatic menageries to complex, mission-driven institutions. A fairly recent trend is the emergence of aquariums as commercial enterprises, often built as entertainment centers in shopping malls and hotels or as stand-alone facilities. Unlike aquatic theme parks, which have existed for decades, these new aquariums are similar in architecture and exhibit design to the nonprofit aquariums. Some of these commercial facilities have created new kinds of immersion exhibits that take visitors underwater, bringing them closer to the marine animals than when viewed through flat windows. This trend towards commercial aquariums will continue, but the high cost of building and operating these facilities will limit their numbers.

Administrators of mission-driven nonprofit aquariums, especially those that rely on government grants and subsidies, have already learned that to survive they must operate as businesses. While increasing the aquarium's entertainment value to attract crowds and generate revenue, they must also strive to maintain a balance between over-commercialization and remaining true to their educational and scientific missions. But with so many new aquariums now in existence, will crowds go elsewhere to seek other entertainment venues? If so, how will this affect the ability of aquariums to meet their future commitments to education, research, and conservation, as well as their ever-increasing financial requirements?

Degradation of marine and freshwater ecosystems will surely be among the most important problems the world will face in coming decades. Aquariums will become focal centers for discussing conservation

issues, spearheading programs to protect and restore habitats, and working to save threatened and endangered species. As windows into our streams, lakes, and oceans, aquariums will reflect the changes occurring beneath the surface that are out of sight of most people but must not be out of mind for any of us. Sadly, more aquarium exhibits in the future will also display "last of their kind" organisms, especially those from freshwater habitats where species are often more vulnerable than in marine environments.

Paradoxically, aquariums are in the awkward position of protecting animals and plants in the same environments from which they must collect their display specimens. The solution to this conflict is increased emphasis on captive breeding and cultivation programs. Already aquariums are growing greater numbers of certain organisms than are needed for exhibit purposes, such as living corals. This raises the prospect that someday aquarium collections may become valuable repositories of genetic diversity that will be important in restoring coral reefs. If catastrophic coral die-offs continue, such as those that affected reefs throughout the world in 1998, this may become a very real possibility. Similar scenarios could involve many other freshwater and marine organisms maintained by aquariums.

Aquariums cannot possibly save every threatened or endangered species through breeding programs. Their focus will have to be on conservation, especially preservation of wild habitats. New exhibits will not only inspire and teach; they will be directly linked to field conservation projects and research, activities that will help ensure the continued existence of wild places and the creatures that live in them.

With each passing year we are increasingly removed from the natural world, bombarded by messages touting instant gratification and promoting frivolous amusement. Public aquariums offer a refreshing change, gently challenging people to contemplate worlds beyond their own spheres of everyday reality. While many today have donned masks or scuba gear and peered beneath the surface of lakes and coastal seas, none can completely comprehend the immense depth and breadth of the waters covering our planet. A visit to a public aquarium provides an opportunity for everyone to glimpse the true nature of our world. It is, after all, an ocean planet.

The images captured by photographer Wayne Levin in this book portray what my words cannot express— that the real essence of the aquarium experience is the joy of discovery.

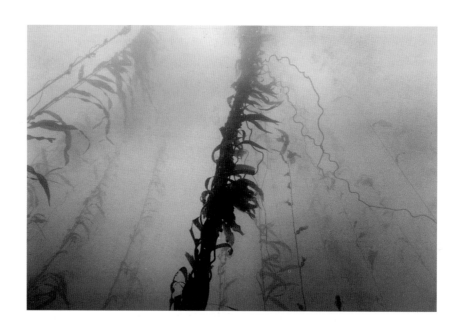

Kelp forest, Monterey, California

Shadows of Abundance

Frank Stewart

Lisa and I take our two-year-old, Emma, to the Waikīkī Aquarium. I'm hoping to see the exhibits through Beginner's Mind (Emma's) and Artist's Mind (Wayne Levin's). The surrounding parks are crowded with Sunday afternoon diversity: an old man in a red tank top printed with the words "Born Wicked"; a woman in a white hat with a white dog and an alligator handbag; a skinny teenager too tall for his Razor scooter; Girl Scouts flying an enormous kite shaped like a green bumblebee. Out of the trees, fairy terns rise and wheel seaward. Nearby, the ocean is even more crowded with oddities; from my terrestrial viewpoint, however, I can see little of the marine life at the surface, and none below—though that's where 90 percent of the Earth's biomass lives: from diatoms to blue whales, krill to spinner dolphins, every spoonful a soup of 100 to 100,000 microbeasts.

We pay at the door and plunge into the aquarium's darkened interior. Arrays of glass cells, day-glo colors on wavering stalks and darting fins—the undersea world on display a few cubic yards at a time. Some of the smaller windows contain just one or two species of marine animal: giant clam, daisy coral, butterfly-fish. But most glass cubes present a grouping of species: feathery blue hydroids, green sea stars, and red-and-black urchins that look like Disneyfied cluster bombs. Odorless, soundless, deathless. Only the largest tank reveals the restless movement of offshore predators. Here the big fish show their stuff—sharks, rays, and jacks—probing the tank's boundaries, its transparent right angles, its cold, glass wall on the near side of which a row of bug-eyed mammals ogle. Several hundred million years older than ours, Fish-Mind stares outward; Mammal-Mind gazes in.

Entranced before the large tank of silver rockets, we stand with our backs to a set of elevated bleachers, as if we were in a darkened theater before a brightly lit stage. We watch for a long time, but the production appears to have no plot, no main characters; the dialogue is inaudible. The players have eyes and mouths but lack the expressive faces of the animals in Emma's collection of fantasy creatures at home. Restless, Emma sprints for the door, to the open air and sunlight. Just beyond the low fence, the Pacific Ocean rip-

ples and scutters over the reef. Aquamarine sky, aquamarine ocean, and clouds zinc-blue on the horizon. In the salt air and ultraviolet rays, our pores open like pink coral polyps.

A loudspeaker announces it's feeding time for the monk seals, so we climb a few steps and stand behind a rail to watch a young man and woman throw fish (presumably not from the aquarium displays) to three large, nearly extinct sea mammals. The seals honk loudly from the backs of their throats. Emma's eyes are wide. Plot, drama, and dialogue most basic. But the sensations are either too much or not enough. She wiggles down and heads for the lawn to practice running in circles, honking empathic cries octaves higher than those of the seals.

Ordinary visitors, we've made our way randomly and haltingly, like moths, through the well-planned galleries, ignored the labels and explanations printed on the walls, and emerged more or less uninformed in any particularly scientific way. (The real science and conservation go on behind the curtain: in public-education programs, field trips, and special events.) But we've had fun. We go home pleased, agreeing that, on a Sunday afternoon, the effect of this small, exquisite aquarium has been not so much to inform us oceanographically as to get a valuable something into our eyes and hearts and to lodge it there for a good long time.

But what kind of perception have we gained in shadowy rooms where the unframed and abundant ocean has been tortured into acrylic cubes and tubes, then squeezed by reflected light rays through the pinholes of our tiny, highly biased orbs? Navigating by random fits and starts of attention, we are like tourists on a budget and in a hurry, neglecting to learn the customs of the natives or acquire even a word or two of their languages—ancient tongues humans forgot long ago how to speak.

Art often contains its subjects in framed displays, too. Like stage sets, the works of painters and photographers compress abundance and diversity, impose artificial order and design, simulate and translate. Are art and aquariums desertions of the real? By surrendering to their compressed visions, do we understand the world less rather than more?

In his book *The Conquest of Abundance*, published posthumously in 1999, philosopher of science Paul Feyerabend reminds readers that we live in a world "abundant beyond our wildest imagination," yet only a tiny fraction of this abundance affects our minds. This is a blessing, of course. If we were to perceive the plenitude that our nerve endings are capable of reporting—uninterpreted by analysis, unsimplified by abstrac-

tion, uncataloged by the subconscious, and unoccluded by habits of cultural learning—we would be paralyzed. (William Blake says no, we would be in paradise, which he takes to be the opposite of paralysis.) Like all sensory creatures, we erase parts of the world, relegate others to marginal places where they disappear. The abstract "stage settings" we create then stand in place of the ecstatic, nongeometric world constantly flowing in and out of us, from the tiny labyrinths in our ears to the edges of the cosmos. These stage sets are our worldview, Feyerabend says: they are how we think and what we think about. Simplified models of the world—with their fixed contours and rigid forms—overpower the strange, the idiosyncratic, and the wild. In Feyerabend's phrase, they "conquer abundance." And they are powerfully successful, even when profoundly benighted. It's only with a great effort of empathy and imagination that we keep in mind how much the window's glass bars us from the world's abundance, how much of life the symmetry of its frame erases.

As an example, the Waikīkī Aquarium has on display about 425 species of marine creatures, including invertebrates—a remarkable diversity considering Hawai'i has a total of only about 450 species of reef and shore fishes. Throughout the world's oceans, however, there may be as many as 450 species of sharks alone—from the massive whale shark, up to fifty feet long and weighing nearly fifteen tons, to the spined pygmy shark, flashing with bioluminescence on belly and spine and measuring seven to eight inches long. How, then, do we make real for ourselves the diversity of even this single category of animal?

And once knowing of such a diversity, how do we display and make comprehensible our destruction of it? Each year, 600,000 to 700,000 tons of sharks are slaughtered by humans, equaling 100,000,000 sharks per year, 11,400 sharks per hour. Such numbers are far too large for our imaginations. They are the numbers of a holocaust. Would it help to realize truly the presence of a single shark?

Biologist E. O. Wilson quotes the experience of naturalist Hugh Edwards. Lowered in a shark cage off Western Australia in 1976, Edwards turned and saw a large male great white shark closing to within ten feet of him.

In all our lives there are milestones, important moments we remember long after. . . . For the brief time of his appearance I drank in every detail of the shark—his eyes, black as night; the magnificent body; the long gill slits slightly flaring; the wicked white teeth; the pectoral fins like the wings of a large aeroplane; and above all the poise and balance in the water and the feeling

conveyed of strength, power, and intelligence. To see the shark alive was a revelation. He was strong, he was beautiful. No dead shark or second-hand account could convey the vitality and presence of the live creature. A few seconds face to face were worth more than all the years of hearsay, pictures, and slack-jawed corpses.

During the face-to-face meeting, Edwards' understanding becomes "unframed," and the shark becomes "lodged in his eye," so to speak—no longer impersonal, no longer diminished by the window's cool, dispossessing geometry. At their best, with effort from our imaginations, perhaps aquariums can, at certain moments, do something similar: introduce us face-to-face to a real presence.

In a photograph by Wayne Levin, a school of *akule* (bigeye scad) off the Kona coast of the Big Island surges and blossoms like a single organism with multiple petals, a dandelion or chrysanthemum blowing in the current. Each individual maintains a precise distance from the others, all turning together, speeding up and slowing down in three liquid dimensions.

Clearly, Levin's eye is not interested much in cold facts and numbers. Instead, his genius is somehow to overpower the boundaries of the photograph's frame. Levin shows us not *akule* but the presence of *akule*. Not a frozen moment of the real (after all, the real can never be frozen without killing it), nor the world transfixed; rather, the world transfigured. We become "rapt," seized by mystery. As William Blake put it, the artist helps us see through the eye "an Innumerable company"—what I have referred to as abundance.

How is Levin able to do this except by restoring us to a sort of Beginner's Mind, helping us untrain our angular, stiff-jointed vision. His luminous, precisely focused arrangements of light and shadows open a channel into wonder—not about a certain fish species, but about the breadth of variation, the unceasing heartbeat, an interior repose and wild orderliness of the cosmos. If we look long enough into these windows, our attentiveness begins to feel like worship, begins to call us to an unspoken responsibility of some kind— and finally to a humility that exceeds us. Our subjectivity vanishes, and we feel the world's circumference enlarging, gazing back at us, each point in the vastness an eye in its own right.

Notes on Photographs

Cover (outer): School of *akule* swimming over sandy bottom in Kealakekua Bay, Hawai'i.

Opposite title page: Schoolgirl viewing great white shark head in case, while other schoolchildren view tank exhibit with blacktip shark, Suma Aquarium, Kobe, Japan.

Dedication page: Circling *akule* over sandy bottom in Kealakekua Bay, Hawai'i.

Opposite contents page: Stingray passing over tube with escalator, Hakejima Sea Paradise, Yokohama, Japan.

Page 15: Goatfishes swim over sandy bottom kicked up by wave action, Kealakekua Bay, Hawai'i.

Page 21: Tightly packed school of *akule*. The predators, jacks, causing the condensation of the school are barely visible. Kealakekua Bay, Hawai'i.

Page 25: Looking down while free diving into a school of *akule*, Kealakekua Bay, Hawai'i.

Page 29: Schooling fish exhibit at Monterey Bay Aquarium, California.

Page 31: Jellyfish exhibit at Monterey Bay Aquarium, California.

Page 33: Ocean sunfish, with bluefin tuna in background, Tokyo Sea Life Park, Japan.

Page 35: Beluga whale, Hakejima Sea Paradise, Yokohama, Japan.

Page 41: Jellyfish tank, Aquarium of the Pacific, Long Beach, California.

Page 43: Sunfish exhibit (netting probably used to protect sunfish from colliding with hard sides of the tank), Kaiyukan Aquarium, Osaka, Japan.

Page 45: Diver cleaning tank at Aquarium of the Pacific, Long Beach, California.

Page 47: Diver swims with assorted large fish in circular tank at Steinhart Aquarium, San Francisco, California. Oceanic whitetip shark depicted in wall painting below.

Page 49: Whale shark in huge main tank and green sea turtle in a side tank, Kaiyukan Aquarium, Osaka, Japan.

Page 51: View of escalator tube from above, Hakejima Sea Paradise, Yokohama, Japan.

Acknowledgments

We wish to acknowledge the generous support of Mary Belanger and Elise Levin, Joseph and Florence Belanger, Gavan Daws, Jon and Mariluz Hopcia, Fran Kaufman, Robert Koch, Keith Leber, Elaine Mayes, Susumu Michizoe, Andy Pate, Stephen Rosenberg, Ada Takahashi, and Lee Tepley.

W. L. and T. F.

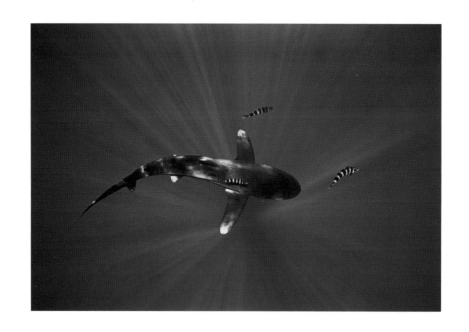

Oceanic whitetip shark and pilotfishes, Kona, Hawai‘i

Biographical Information

Wayne Levin's photographs have appeared in magazines including *Aperture, Ocean Realm, American Photographer,* and *Hemispheres.* His books include *Kalaupapa: A Portrait,* and *Preservations.* He was one of the principal photographers for *Kahoʻolawe: Nā Leo o Kanaloa.* A National Endowment for the Arts Fellow, Wayne Levin has photographs in collections of the Museum of Modern Art, New York City; Bishop Museum, Honolulu; and the Hawaiʻi State Foundation on Culture and the Arts. His most recent book, *Through a Liquid Mirror,* done in collaboration with Thomas Farber, was voted 1998 Book of the Year by the Hawaiʻi Book Publishers Association.

Awarded Guggenheim and (three times) National Endowment for the Arts fellowships for fiction and creative nonfiction, Thomas Farber has been Fulbright scholar, recipient of the Dorothea Lange–Paul Taylor Prize, and Rockefeller scholar at Bellagio Center. His many books include *On Water* and *The Face of the Deep.* Formerly Visiting Distinguished Writer at the University of Hawaiʻi, Visiting Fellow at the East-West Center, and Fulbright Fellow for Pacific Island Studies, he is a senior lecturer in English at the University of California, Berkeley.

Bruce A. Carlson, Director of the Waikīkī Aquarium in Honolulu since 1990, was a Peace Corps volunteer at the University of the South Pacific in Suva, Fiji, before coming to Hawaiʻi in 1975. His association with the Waikīkī Aquarium began the following year as a University of Hawaiʻi student worker. During his tenure at the Aquarium the facility has undergone major renovations and has received many national awards for excellence. He and his wife are avid scuba divers, and his underwater videos have been televised both locally and nationally.

Frank Stewart's books include *The Presence of Whales, A Natural History of Nature Writing,* and *A World Between Waves.* In addition, his essays and poetry have been published and anthologized widely. He has received the Whiting Writers Award and other prizes. He is currently editor of *Mānoa: A Pacific Journal of International Writing,* published by University of Hawaiʻi Press.